ENCYCLOPEDIA OF RAINBOWS

Our World Organized by Color

JULIE SEABROOK REAM

CHRONICLE BOOKS

SAN FRANCISCO

Library of Congress Cataloging-in-Publication Data available.

ISBN 978-1-4521-5533-3

Manufactured in China

Designed by Alice Chau
Illustrations by Arthur Mount

10 9 8 7 6 5 4 3 2

Chronicle Books LLC
680 Second Street
San Francisco, California 94107
www.chroniclebooks.com

For Eliza, my rainbow girl

CONTENTS

INTRODUCTION

"What's your favorite color?" is such a seemingly simple question, yet I could never come up with an answer. Finally one day when my daughter came home from preschool and asked the question, something clicked: I can't pick a favorite color because I like the way they all look together, in rainbow order. She nodded, and found this to be a perfectly acceptable answer. We got out my old set of colored pencils, organized them into a rainbow, and posted the photograph to Instagram. I was instantly filled with joy that I was encouraging my daughter to appreciate every color of the rainbow, so we decided to create one hundred of these rainbows together, in one hundred days.

Suddenly I was seeing rainbow possibilities everywhere. Each new discovery of a colorful object set me on a path to find more colorful varieties. When I found a bright piece of green jade, I started to wonder what other colors of rocks existed. Were there brilliantly colored blue rocks, too? And what about yellow? Could I make a whole rainbow out of stones? That creative experiment became the inspiration for this book.

As I continued to gather objects with my daughter, I was having as much fun learning about the subjects as I was making the rainbows. I discovered there are in fact blue stones called lapis lazuli and learned red eggs are laid by Black Copper Marans chickens. I had no idea how many different kinds of pencils are out there—there are pencils for writing, drafting, copying, carpentry, marking on glass, and even voting in election booths. I learned that an orange French cheese, Pavé du Nord, is named for its resemblance in shape to cobblestones in its area of origin. There's even a warty yellow variety of gourd that goes by the name of Lunch Lady. Each rainbow I started opened up a whole new world for exploration.

This book gathers these rainbows together into a sort of encyclopedia of things from nature and the manmade world. Of course, this is an "encyclopedia" in the loosest sense: I could spend years gathering as many rainbows as possible and still come nowhere close to revealing all there is to appreciate. But I've rounded up objects from all corners of the earth here, from feathers and minerals to office

supplies and food, and laid them out into this collection of rainbows. They range from geodes found in Madagascar to gadgets you might have in your kitchen cabinet. Grouped together and organized by hue, what emerges is the amazing array of color to be found everywhere in our world.

This project rekindled my love of nature and putting things in order. My extended family growing up was a strange combination of artists and scientists, and as a child, I loved learning about nature. I studied botany in college, but found the classification systems lacked the beauty that drew me to nature in the first place. It didn't take me long to realize that my true calling was not in a science lab, but in an art studio. With this project, I found a balance to these seemingly opposite worlds: the sense of discovery, exploration, and organization from science, mixed with a love of artistic color and form. It is more than just a collection of beautiful objects—it's an appreciation of what they are and where they come from. For me, it was the most gratifying way possible to rediscover nature and beyond, and it was even more rewarding if I could bring others along on the journey.

There is a special kind of delight in the revelation of objects gathered in every color. So often, the first object that would become the starting point for a rainbow was just sitting in plain sight, either in my home or throughout the paths of my daily life, and discovering it was simply a matter of adjusting the way I saw the world. When I came across an inspiration point—like an orange Monarch butterfly fluttering through the garden—I put on my rainbow-colored glasses and set about finding the other colors of butterflies in the world. I hope these photos inspire you to put on your own rainbow-colored glasses and view the world in a new way too.

THE NATUR

BUTTERFLIES

1. *Pink Glasswing*
2. *Eighty-Nine Butterfly*
3. *Blood-Red Glider*
4. *Common Red Glider*
5. *Crimson Prince*
6. *Aulestes Doctor*
7. *"BD" Butterfly*
8. *American Monarch*
9. *Gaudy Commodore*
10. *Orange Albatross*
11. *Gulf Fritillary*
12. *Silver-Striped Charaxes*
13. *Cruiser*
14. *Noble Swallowtail*
15. *Orange Tip*
16. *Golden Jezebel*
17. *Apricot Sulphur*
18. *Tailed Sulphur*
19. *Orange-Barred Sulphur*
20. *Chocolate Albatross*
21. *King Swallowtail*
22. *Orange Gull*
23. *Queen Swallowtail*
24. *Ornate Green Charaxes*
25. *Tailed Jay*
26. *Rajah Brooke's Birdwing*
27. *Cape York Birdwing*
28. *Peacock Swallowtail*
29. *Red Flasher*
30. *Queen Flasher*
31. *Blue Triangle*
32. *Larger Striped Swordtail*
33. *Turquoise Emperor*
34. *Blue Mountain Swallowtail*
35. *Giant Blue Morpho*
36. *Mottled Leafwing*
37. *Hercules Oakblue*
38. *Leprieur's Glory*
39. *Blue Morpho*
40. *Spotted Lilac Tree Nymph*
41. *Purple Spotted Swallowtail*
42. *Agathina Emperor*
43. *Fire Opal Leafwing*

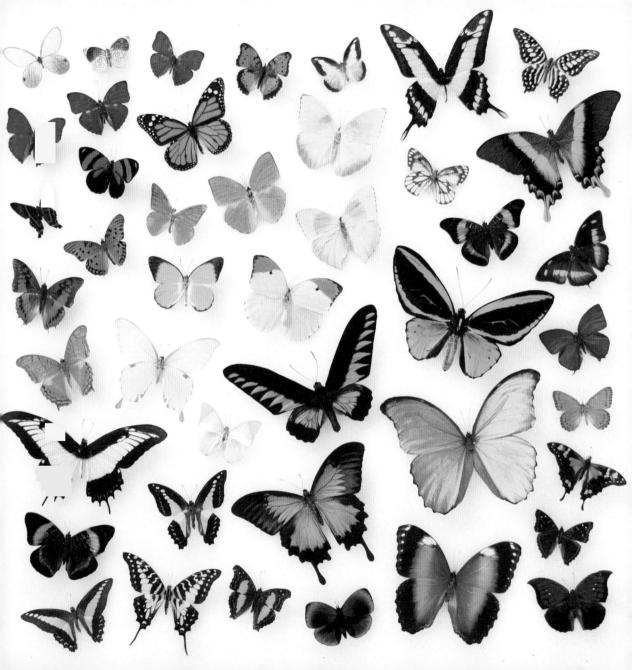

INSECTS

1. *Yellow-Spotted Flying Stick*
2. *Rainbow Milkweed Locust*
3. *Blood-Red Lanternfly*
4. *Red-Green Lanternfly*
5. *Javanese Lichen Stick Insect*
6. *Man-Faced Stink Bug*
7. *Bull Horn Beetle*
8. *Violin Beetle*
9. *Stag Beetle*
10. *Variegated Flutterer Dragonfly*
11. *Hercules Beetle*
12. *Yellow Umbrella Stick Insect*
13. *Green Glasswing Cicada*
14. *Spoonwing Lacewing*
15. *Sawtooth Stag Beetle*
16. *Emerald Jewel Beetle*
17. *Walking Leaf*
18. *Orchid Bee*
19. *Katydid*
20. *Glorious Scarab Beetle*
21. *Flower Beetle*
22. *Stream Glory Damselfly*
23. *Tarantula Hawk Wasp*
24. *Dung Beetle*
25. *Blue Carpenter Bee*

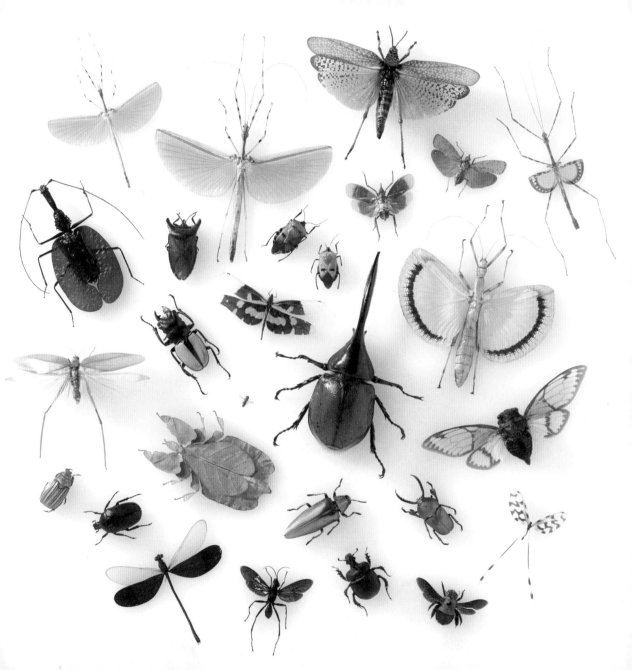

FEATHERS

1. *African Grey Parrot Tail Feathers*
2. *Moluccan Cockatoo Crest Feathers*
3. *Moluccan Cockatoo Body Feather*
4. *Yellow Amazon Parrot Wing Feathers*
5. *Moluccan Cockatoo Wing Feather*
6. *Perfect Lorikeet Wing Feather*
7. *Red-Shouldered Macaw Wing Feather*
8. *Green Amazon Parrot Wing Feathers*
9. *Blue Monk Parakeet Body Feathers*
10. *Blue Monk Parakeet Wing Feathers*
11. *Green-Winged Macaw Wing Feather*
12. *Steller's Jay Wing Feather*
13. *Indian Roller Wing Feather*
14. *Blue-and-Gold Macaw Wing Feathers*
15. *Mallard Wing Feather*
16. *Helmeted Guinea Fowl Body Feather*
17. *Red-Tailed Hawk Secondary Wing Feather*

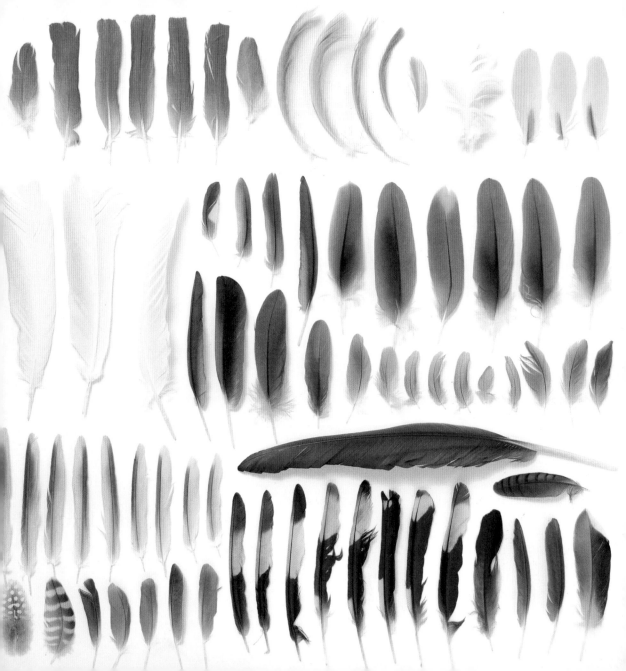

EGGS

1. *Black Copper Marans Chicken*
2. *Barnevelder Chicken*
3. *Rhode Island Red Chicken*
4. *Buff Orpington Chicken*
5. *Indian Peafowl*
6. *Narragansett Turkey*
7. *Button Quail*
8. *Pearl Guinea Fowl*
9. *Bantam Chicken*
10. *Royal Palm Turkey*
11. *Chukar Partridge*
12. *Greater Rhea*
13. *Olive Egger Chicken*
14. *Ring-Necked Pheasant*
15. *Double-Wattled Cassowary*
16. *Easter Egger Chicken*
17. *Ameraucana Chicken*
18. *Mute Swan*
19. *Mallard Duck*
20. *Rouen Duck*
21. *Runner Duck*
22. *Emu*
23. *Coturnix Quail*
24. *Chilean Tinamou*
25. *Cayuga Duck*
26. *Pekin Duck*
27. *Embden Goose*
28. *King Pigeon*
29. *Bobwhite Quail*
30. *Zebra Finch*

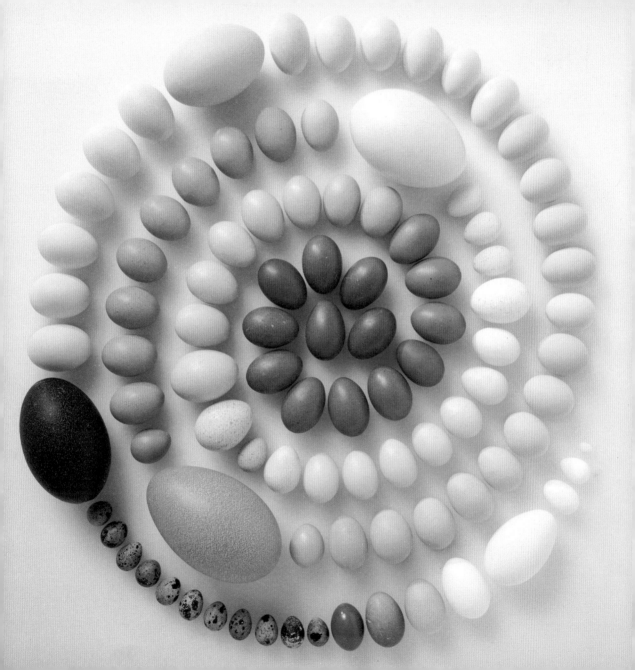

SHELLS

1. Pink-Mouth Murex
2. Rose-Petal Tellin
3. Japanese Moon Scallop
4. Noble Scallop
5. Strawberry Top
6. American Thorny Oyster
7. Pear Triton
8. Lion's Paw Scallop
9. Yoka Star Turban
10. Starry Moon Snail
11. Lined Moon Snail
12. Florida Fighting Conch
13. Florida Horse Conch
14. Indian Volute
15. West Indian Prickly Cockle
16. Periwinkle Snail
17. Money Cowrie
18. Great Green Turban
19. Cone-Shaped Top
20. Elephant Tusk

21. Common Turtle Limpet
22. Giant Heart Cockle
23. Jingle Shell
24. Fischer's Gaza
25. Lightning Whelk
26. Variable Abalone
27. Purple Top Cowrie
28. Violet Coral Shell
29. Purple Pacific Drupe
30. Florida Prickly Cockle
31. Purple Tiger Cowrie
32. Northern Quahog
33. Calico Scallop
34. Juvenile Northern Quahog
35. Snake's Head Cowrie
36. Honey Cowrie
37. Chiragra Spider Conch
38. Beech Cone
39. Marbled Cone
40. Lettered Cone

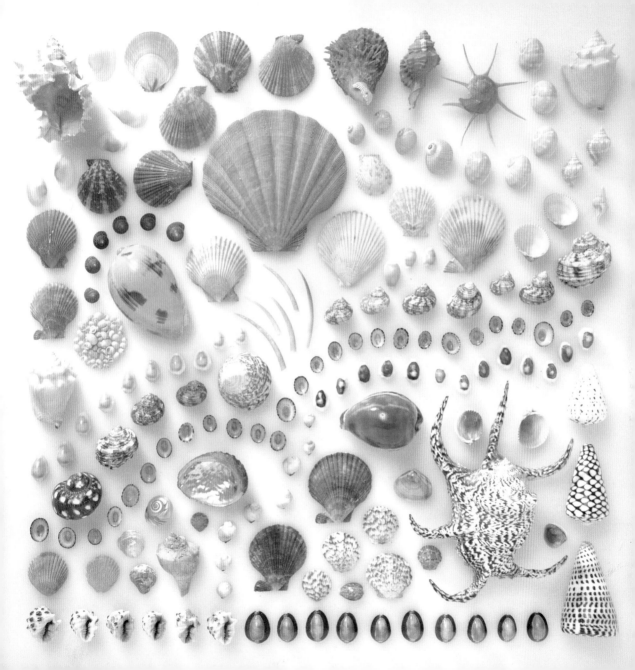

SEA LIFE

1. *Deep Water Philippine Sea Urchin*
2. *Sputnik Sea Urchin*
3. *Rock-Boring Urchin*
4. *Whip Coral*
5. *Organ-Pipe Coral*
6. *Common Starfish*
7. *Crown-of-Thorns Starfish*
8. *White Sea Urchin*
9. *Cushion Sea Star*
10. *Spotted Sea Star*
11. *Sand Sifting Sea Star*
12. *Sea Fan*
13. *Green Sea Urchin*
14. *Green Sea Urchin with Spines*
15. *Blue Starfish*
16. *Blue Ridge Coral*
17. *Shingle Urchin*
18. *Mushroom Urchin*
19. *Hatpin Sea Urchin Spines*
20. *Barnacle Cluster*

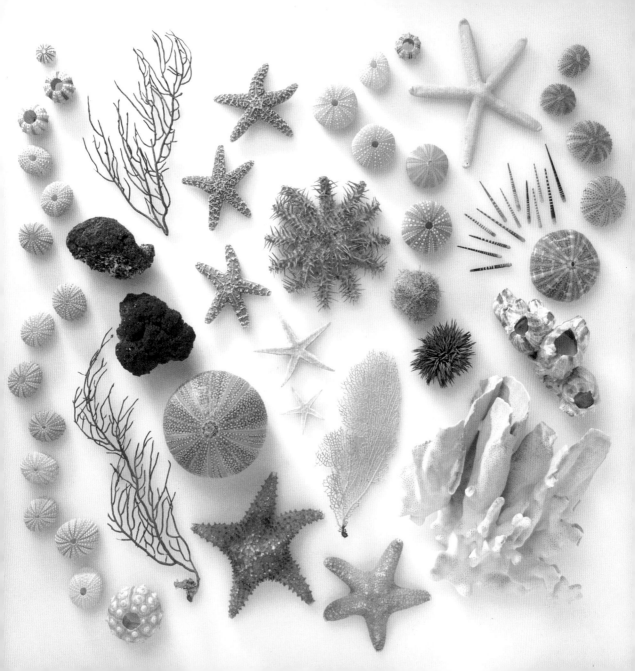

LEAVES

1. *Scarlet Oak*
2. *Sawtooth Oak*
3. *Vernal Witch Hazel*
4. *White Oak*
5. *American Sweet Gum*
6. *Flowering Dogwood*
7. *Japanese Maple*
8. *Staghorn Sumac*
9. *Sugar Maple*
10. *Sassafras*
11. *Peachleaf Willow*
12. *Common Bald Cypress*
13. *Tulip Tree*
14. *Black Oak*
15. *Red Oak*
16. *Juneberry*
17. *Pawpaw*
18. *Common Witch Hazel*

19. *Ohio Buckeye*
20. *Ginkgo*
21. *White Ash*
22. *Bur Oak*
23. *Black Ash*
24. *Swamp White Oak*
25. *Chestnut Oak*
26. *Hedge Maple*
27. *Pin Oak*
28. *Saucer Magnolia*
29. *Osage Orange*
30. *Weeping Willow*
31. *European Beech*
32. *Balm of Gilead*
33. *Washington Hawthorn*
34. *Chinquapin Oak*
35. *Cornelian Cherry Dogwood*
36. *Butternut*

37. *Hardy Catalpa*
38. *Pecan*
39. *Honey Locust*
40. *Sycamore*
41. *Weeping White Mulberry*
42. *White Mulberry*
43. *White Pine*
44. *Concolor Fir*
45. *Lacebark Pine*
46. *Eastern Red Cedar*
47. *Norway Spruce*
48. *White Spruce*
49. *Blue Spruce*
50. *Chokecherry*
51. *White Oak*
52. *American Plum*

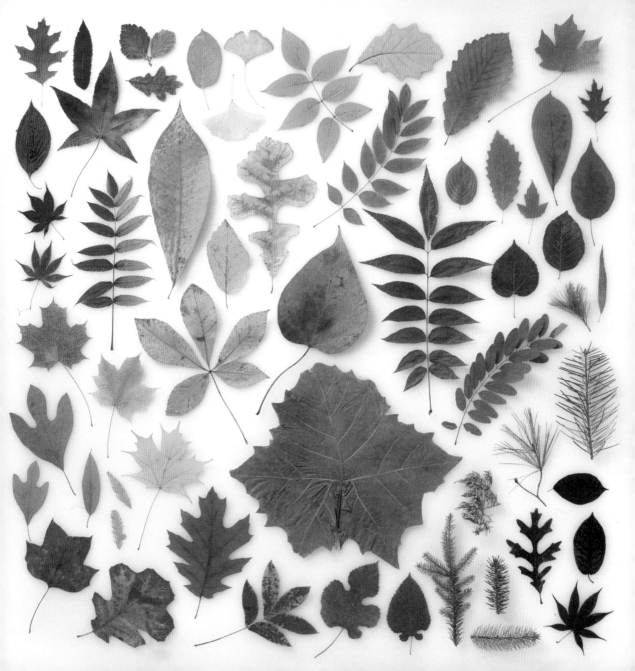

TREE FRUITS

1. *Bing Cherries*
2. *Red Delicious Apple*
3. *Wonderful Pomegranate*
4. *Cripps Pink Apple*
5. *Dapple Dandy Pluots*
6. *Kent Mango*
7. *Red Gold Nectarines*
8. *Jayhaven Peaches*
9. *Red Jacket Apricots*
10. *Braeburn Apple*
11. *Hosui Asian Pear*

12. *Bartlett Pears*
13. *Golden Delicious Apples*
14. *White Kadota Figs*
15. *Seneca Plums*
16. *Granny Smith Apples*
17. *Hass Avocados*
18. *Long John Plums*
19. *Canada Plums*
20. *Black Mission Figs*
21. *Brown Turkey Figs*
22. *Early Magic Plum*

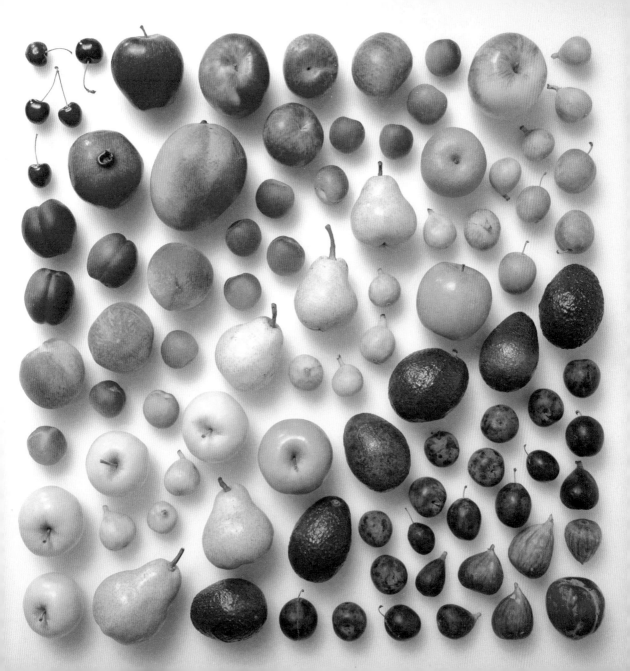

BERRIES

1. *Heritage Red Raspberries*
2. *Red Chief Strawberries*
3. *Aunt Molly's Ground Cherries*
4. *Aunt Molly's Ground Cherries (in husk)*
5. *Anne Raspberries*
6. *Goldie Ground Cherries*
7. *Pixwell Gooseberry Leaves*
8. *Bluecrop Blueberries*
9. *Ouachita Blackberries*
10. *Black Satin Blackberries*

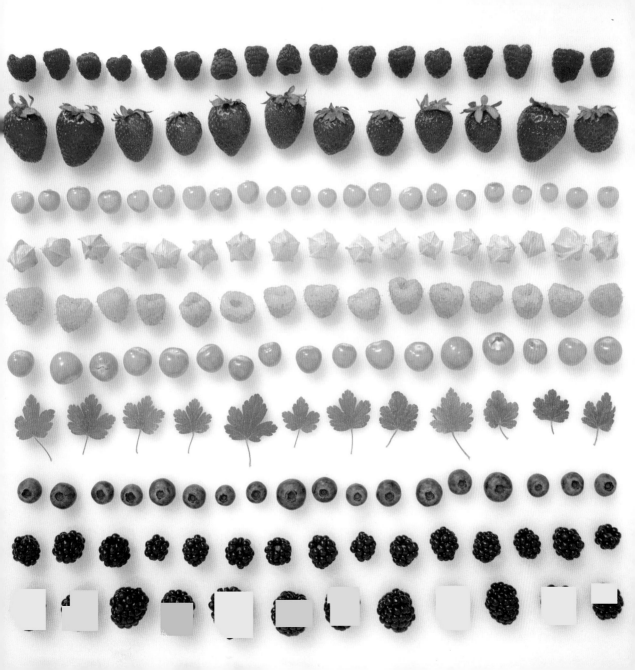

TROPICAL FRUITS

1. Dragon Fruit
2. Pomegranates
3. Red Bananas
4. Blood Orange
5. Navel Orange
6. Red Grapefruit
7. Horned Melon
8. Persimmon
9. Lemon
10. Ground Cherry
11. Quince
12. Pomelo
13. Plantains
14. Star Fruit

15. Cavendish Bananas
16. Mango
17. Pineapple
18. Guava
19. Cherimoya
20. Papaya
21. Green Coconut
22. Limes
23. Key Limes
24. Hass Avocado
25. Passion Fruit
26. Prickly Pear
27. Kiwi
28. Tamarind

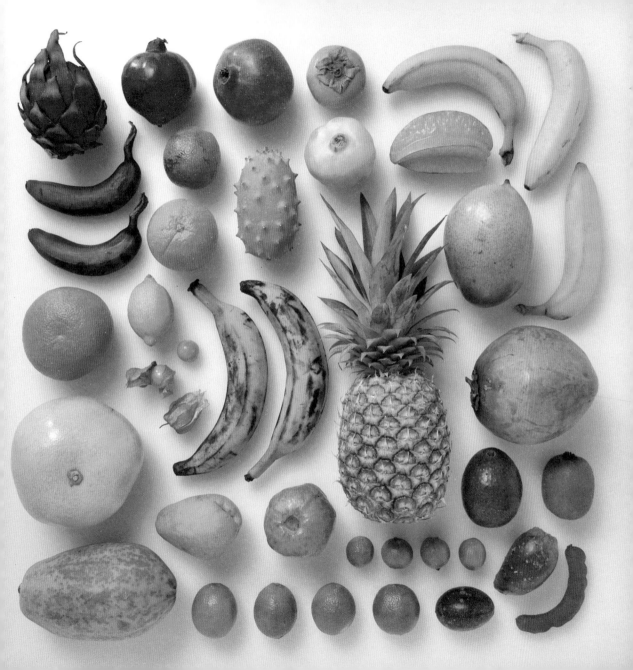

ON THE VINE

1. *Oxheart Tomato*
2. *Pink Plum Tomatoes*
3. *Sweet Marconi Pepper*
4. *Sheepnose Pimento Pepper*
5. *Tigerella Tomatoes*
6. *Hot Rod Serrano Peppers*
7. *Intruder Pepper*
8. *Russian Queen Tomato*
9. *Sunrise Peppers*
10. *Persimmon Tomatoes*
11. *Kellogg's Big Breakfast Tomato*
12. *Orange Habanero Pepper*
13. *Woodle Orange Tomatoes*
14. *Yellow Ruffled Tomato*
15. *Copia Tomato*
16. *Powers Heirloom Tomatoes*
17. *Garden Peach Tomatoes*
18. *Plum Lemon Tomatoes*
19. *Banana Legs Tomato*
20. *Small Wonder Spaghetti Squash*
21. *Hungarian Hot Wax Peppers*
22. *Yellow Stuffer Tomatoes*

23. *Big Rainbow Tomato*
24. *Delicata Squash*
25. *Green Sausage Tomatoes*
26. *Mint Julep Tomato*
27. *Crimson Sweet Watermelon*
28. *Green Zebra Tomatoes*
29. *Emerald Evergreen Tomato*
30. *Blue Lake Bush Bean*
31. *Tiburon Poblano Peppers*
32. *Boston Pickling Cucumber*
33. *Shishito Peppers*
34. *Tam Jalapeno Peppers*
35. *Provider Green Beans*
36. *Green Vernissage Tomatoes*
37. *Canadice Grapes*
38. *Fairy Tale Eggplants*
39. *Dancer Eggplant*
40. *Pintung Long Eggplant*
41. *Long Purple Eggplant*
42. *Purple Smudge Tomatoes*
43. *Black Beauty Eggplant*

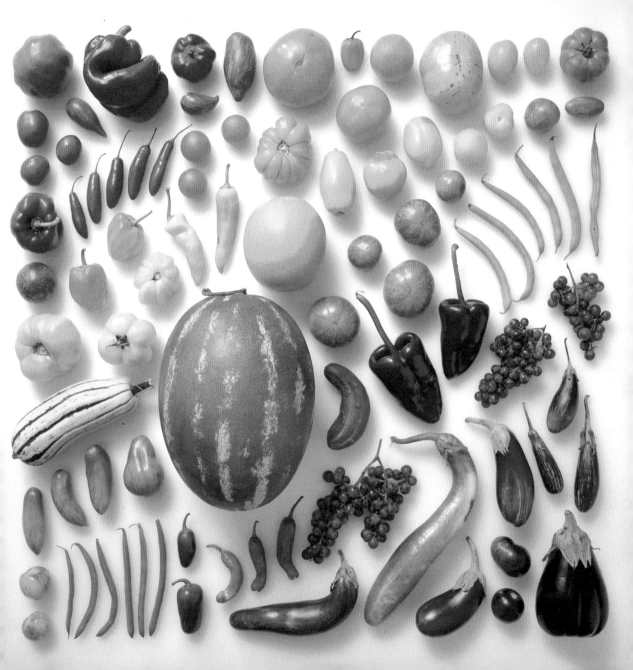

IN THE SOIL

1. *Red Beets*
2. *Chioggia Beets*
3. *Red Radishes*
4. *Red Garnet Sweet Potato*
5. *Beauregard Sweet Potatoes*
6. *Red Potatoes*
7. *Red Creamer Potatoes*
8. *Merida Carrots*
9. *Golden Beets*
10. *Turmerics*
11. *Pearl Onions*

12. *Yellow Carrots*
13. *Fingerling Potatoes*
14. *Jicama*
15. *Kohlrabi*
16. *Green Onions*
17. *Purple Potatoes*
18. *Purple Carrots*
19. *Red Pearl Onions*
20. *Red Onion*
21. *Kotobuki Sweet Potato*
22. *Turnip*

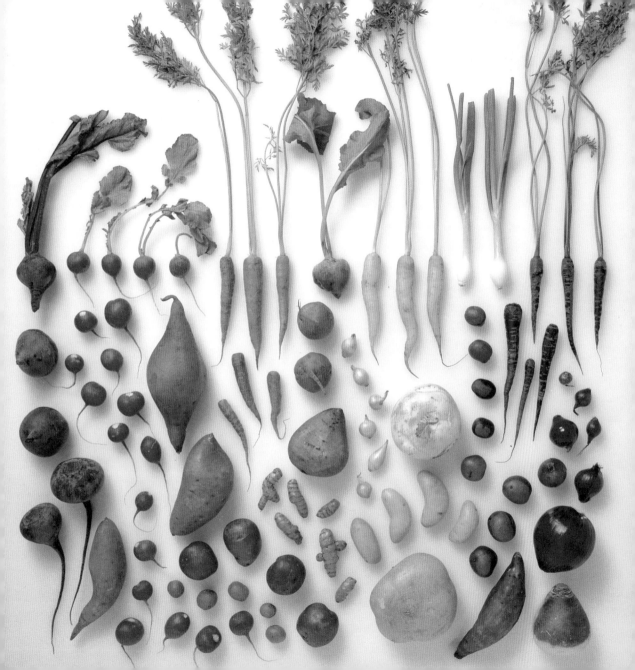

BEANS & LEGUMES

1. *Pink Quartz Beans*
2. *Rajama Indian Pink Beans*
3. *Snow on the Mountain Lima Beans*
4. *Hidatsa Red Beans*
5. *Jacob's Cattle Trout Beans*
6. *Red Anasazi Bean*
7. *Adzuki Beans*
8. *Dixie Speckled Butterpea Lima Bean*
9. *Chinese Red Noodle Bean*
10. *Swedish Brown Bush Bean*
11. *Zuni Gold Bean*
12. *Yellow Split Peas*
13. *Fava Beans*

14. *Hutterite Soup Beans*
15. *Mayacoba Beans*
16. *Heritage d'Or Beans*
17. *Green Split Peas*
18. *Soy Beans*
19. *Mung Beans*
20. *Moonshadow Hyacinth Beans*
21. *Turtle Beans*
22. *Cherokee Trail of Tears Pole Beans*
23. *Scarlet Runner Beans*
24. *Large Speckled Calico Lima Beans*
25. *Good Mother Stallard Pole Beans*

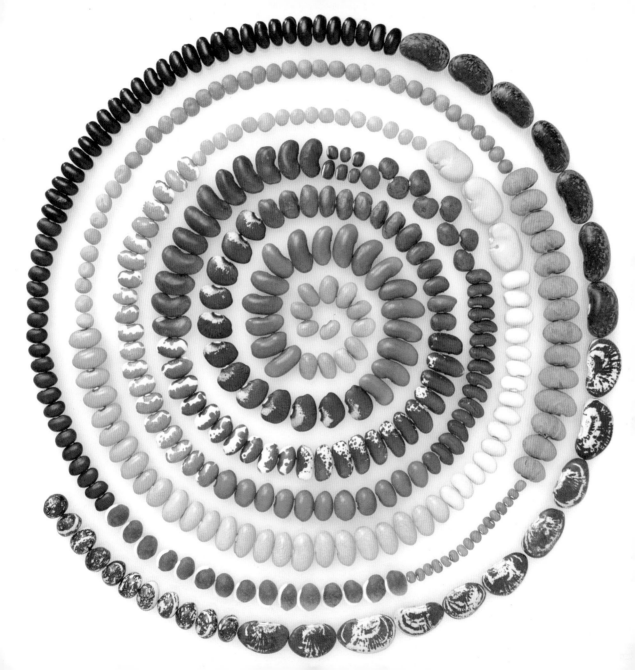

CORN

1 ----
2 ----
3 ----
4 ----
5 ----
6 ----
7 ----
8 ----
9 ----
10 ----
11 ----
12 ----
13 ----
14 ----
15 ----
16 ----
17 ----

1. *Strawberry Popcorn*
2. *Bloody Butcher*
3. *Puka Chullpi & Karu Kay Suni*
4. *Strubbes Orange*
5. *Tom Thumb & Reid's Yellow Dent*
6. *Golden Bantam*
7. *Paraguayan Chipa*
8. *Country Gentleman*
9. *Trucker's Favorite*

10. *Green and Gold Dent*
11. *Green Popcorn*
12. *Oaxacan Green Dent*
13. *Po'suwaegeh Blue*
14. *Dakota Black Popcorn*
15. *Hopi Wiekte*
16. *Chuspi Puka Purple*
17. *Morado Potolero*

SQUASH & GOURDS

1. *Rouge Vif d'Etampes "Cinderella" Pumpkin*
2. *Long Island Cheese Pumpkin*
3. *Galeux d'Eysines Squash*
4. *Gold Nugget Squash*
5. *Porcelain Doll Pumpkin*
6. *One Too Many Pumpkin*
7. *Small Sugar Pumpkin*
8. *Spoon Platoon Gourd*
9. *Warted Gourd*
10. *Connecticut Field Pumpkin*
11. *Spaghetti Squash*
12. *Jaune Gros de Paris Pumpkin*
13. *Crown of Thorns Gourd*
14. *Acorn Squash*
15. *Lunch Lady Gourd*
16. *Sweet Dumpling Squash*

17. *Lil' Pump-Ke-Mon Pumpkin*
18. *Birdhouse Gourd*
19. *Snake Gourd*
20. *Miniature Bottle Gourd*
21. *Canteen Gourd*
22. *Apple Gourd*
23. *Striped Pear Gourd*
24. *Banana Gourd*
25. *Kettle Gourd*
26. *Long Handle Dipper Gourd*
27. *Sweet Mama Squash*
28. *Turban Gourd*
29. *Jarrahdale Pumpkin*
30. *Blue Hubbard Squash*
31. *Musquée de Provence "Fairytale" Pumpkin*

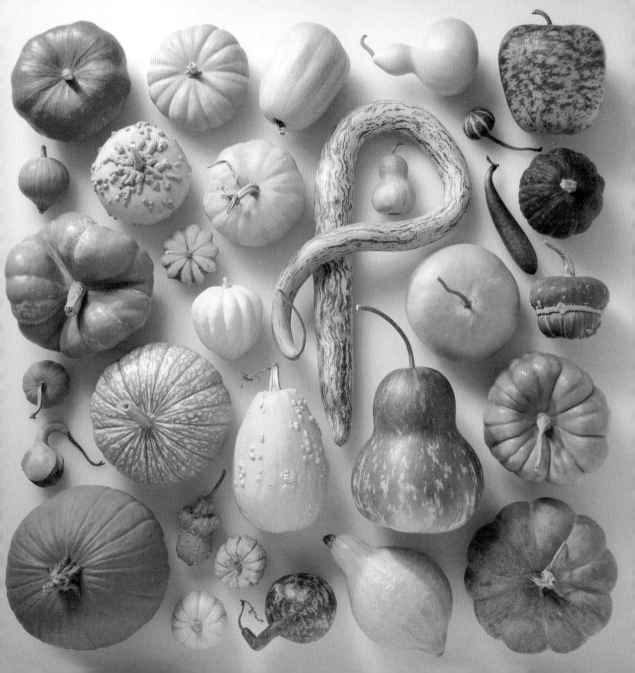

ROSES

1. *Gracia Spray*
2. *Lovely Lydia Spray*
3. *Red Piano Garden*
4. *Red Angel Spray*
5. *Orange Crush Standard*
6. *Caramel Antike Garden*

7. *Tara Standard*
8. *Floribunda*
9. *Little Silver*
10. *Cool Water Standard*
11. *Mon Cherie Spray*

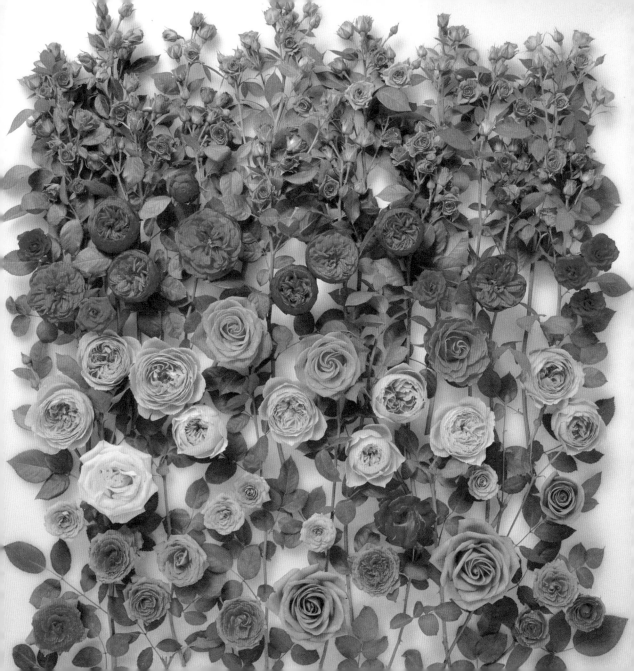

TULIPS

1. *Fancy Frills*
2. *Arlington*
3. *Arie Alkemade's Memory*
4. *Dordogne*
5. *Orca*
6. *Alabama Star*
7. *Super Parrot*
8. *Queen of Night*

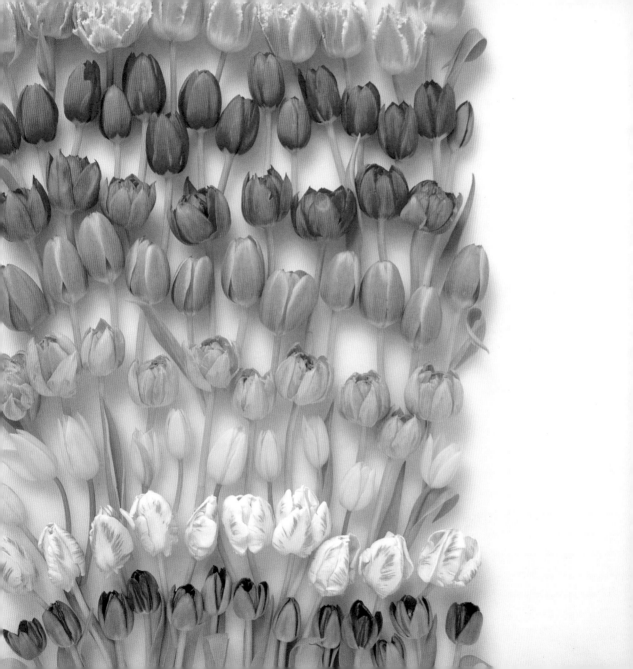

DAISIES

1. *Plot Gerbera Daisy*
2. *Butterfly Kisses Coneflower*
3. *Southern Belle Coneflower*
4. *Rich Raspberry Gerbera Daisy*
5. *Solar Flare Coneflower*
6. *Cheyenne Spirit Coneflower*
7. *Carambole Gerbera Daisy*
8. *Orange Springs Gerbera Daisy*
9. *Mandelina Gerbera Daisy*
10. *Yucatan Coral Gerbera Daisy*
11. *Prairie Sun Black-Eyed Susan*
12. *Chiquita Gerbera Daisy*
13. *Becky Shasta Daisy*
14. *Palm Beach Gerbera Daisy*
15. *Coreopsis Full Moon*
16. *Real Charmer Shasta Daisy*
17. *Anastasia Green Fuji Mum*
18. *Green Jewel Coneflower*
19. *Yoko Ono Button Poms*
20. *Tight & Tidy Aster*
21. *Peachie's Pick Stokes' Aster*
22. *Lollipop Gerbera Daisy*

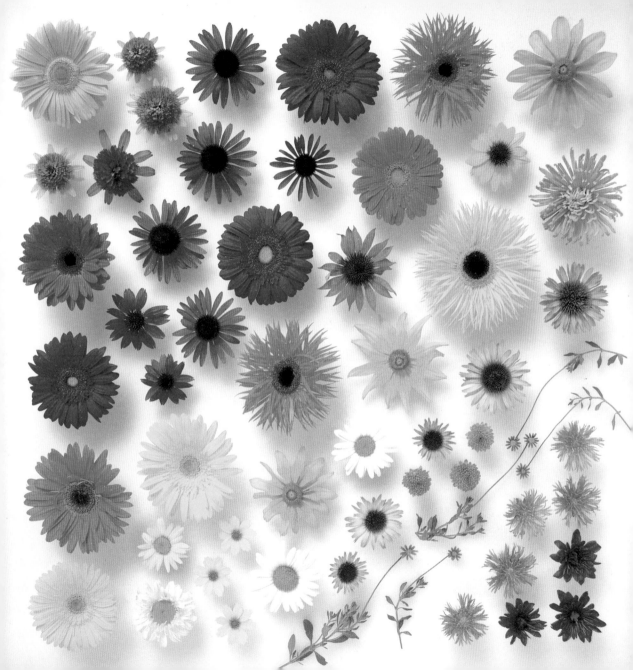

DAHLIAS

1. *Cornel*
2. *Jescot Lingold*
3. *Yellow Button*
4. *Woodland's Merinda*

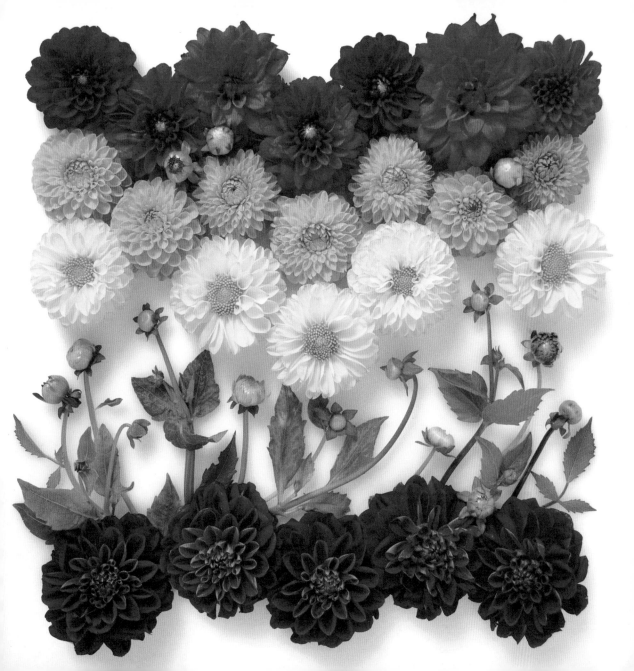

ORCHIDS

1. *Cymbidium*
2. *Mokara*
3. *Oncidium*
4. *Dendrobium*
5. *Phalaenopsis*
6. *Cattleya*

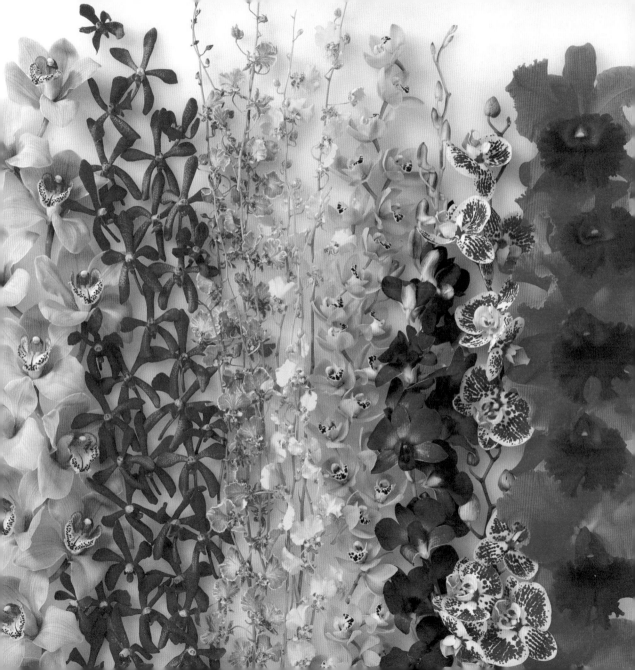

CLIMBING, VINING & TRAILING FLOWERS

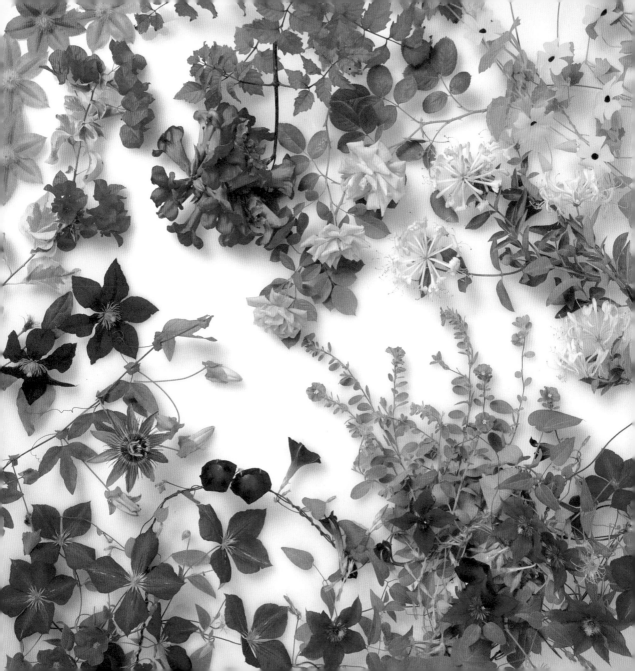

EDIBLE FLOWERS

1. *Bee Balm*
2. *Johnny Jump Up*
3. *Rose*
4. *Clover*
5. *Marigold*
6. *Hibiscus*
7. *Begonia*
8. *Nasturtium*
9. *Pansy*

10. *Calendula*
11. *Basil Leaves*
12. *Nasturtium Leaves*
13. *Borage*
14. *Comfrey*
15. *Anise Hyssop*
16. *Lavender*
17. *Hyssop*

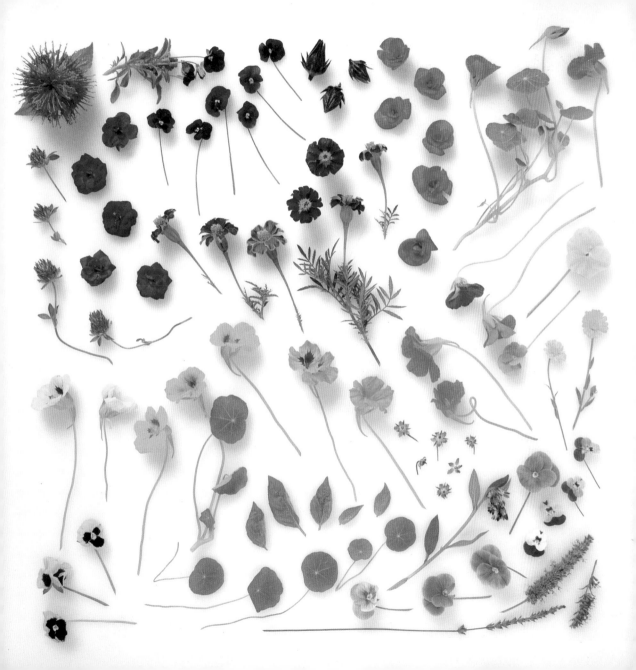

TALL FLOWERS

1. *Foxglove*
2. *Snapdragon*
3. *Larkspur*
4. *Gladiolus*
5. *Bells of Ireland*
6. *Delphinium*

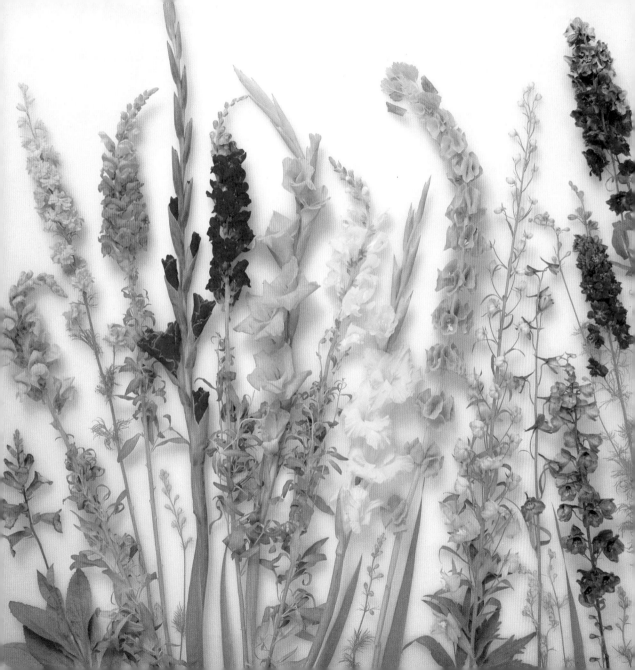

SUMMER FLOWERS

1. *Hydrangea*
2. *Dahlia*
3. *Sunflower*
4. *Gladiolus*
5. *Dianthus*
6. *Delphinium*
7. *Aster*
8. *Clover*

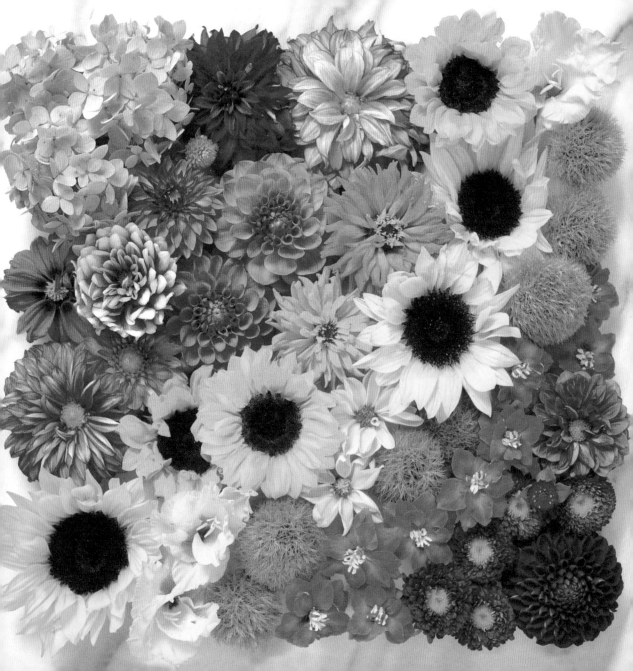

TROPICAL FLOWERS

1. *Mandevilla*
2. *Dendrobium Orchid*
3. *Double Hibiscus*
4. *Painted Lady Hibiscus*
5. *Anthurium*
6. *Protea Pin Cushion*
7. *Abutilon*
8. *Gerbera Daisy*

9. *Bird of Paradise*
10. *Common Hibiscus*
11. *Yellow Trumpetbush*
12. *Plumbago*
13. *Tibouchina*
14. *Passionflower*
15. *African Violet*
16. *Gloxinia*

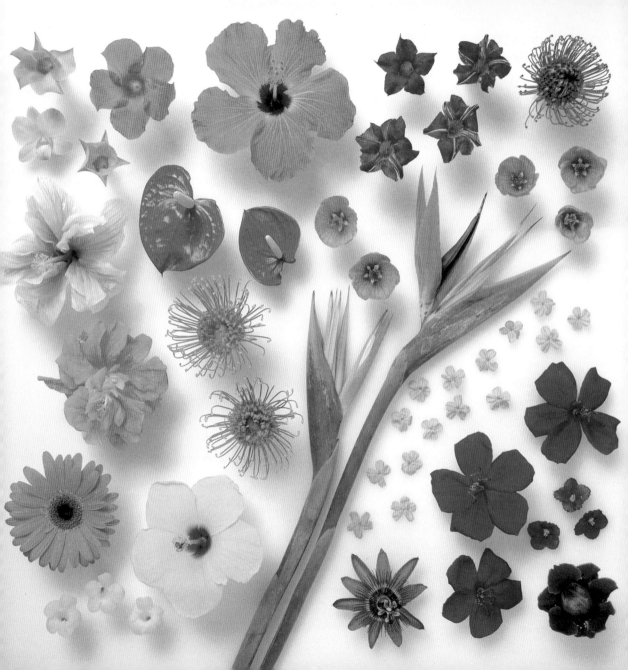

SUCCULENTS & CACTUSES

2 2 1
2 4 5 6
2 3 3
2 10 8 7
11
9 14
17
12
16 15 19
13 20
18 20

1. *Kiwi Aeonium*
2. *Red Moon Cactus*
3. *Orange Moon Cactus*
4. *Yellow Moon Cactus*
5. *Golden Sedum*
6. *Blue Chalksticks*
7. *Burro's Tail*
8. *Aeonium*
9. *Sedum*
10. *Tiger Tooth Aloe*

11. *Crassula*
12. *Zebra Cactus*
13. *Crosby's Compact Jade*
14. *Little Jewel*
15. *Propeller Plant*
16. *Jeweled Crown*
17. *White Mexican Rose*
18. *Peacock Echeveria*
19. *Weeping Jade*
20. *Echeveria "Perle Von Nürnberg"*

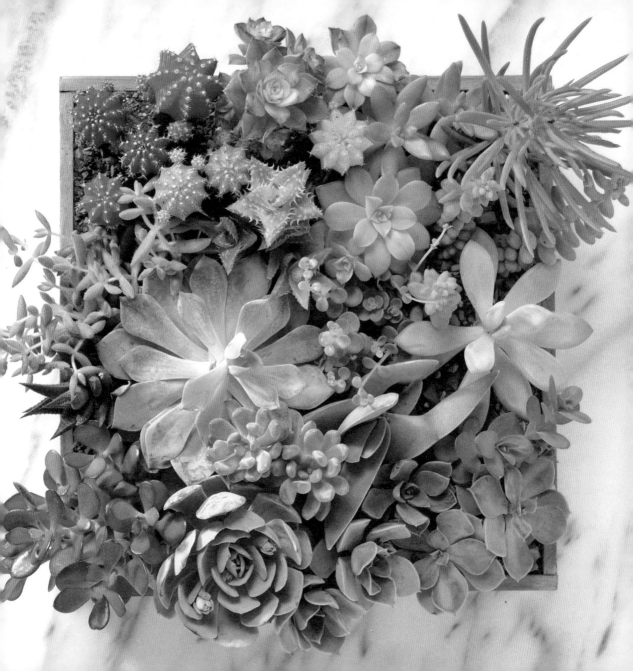

PRESSED FLOWERS

1. *White Gladiolus*
2. *Marshmallow*
3. *Iceland Poppy*
4. *Pink Gladiolus*
5. *Geranium*
6. *California Poppy*
7. *Japanese Kerria*
8. *Black-Eyed Susan Vine*
9. *Tiger Lily*
10. *Rose Petal*
11. *Lesser Celandine*

12. *Shrubby Cinquefoil*
13. *Common Marigold*
14. *Wild Ginger*
15. *Hemlock*
16. *Clayton's Bedstraw*
17. *Stinging Nettle*
18. *Sweet Fennel*
19. *Garden Vetch*
20. *Hydrangea*
21. *Blue Periwinkle*
22. *Spring Crocus*

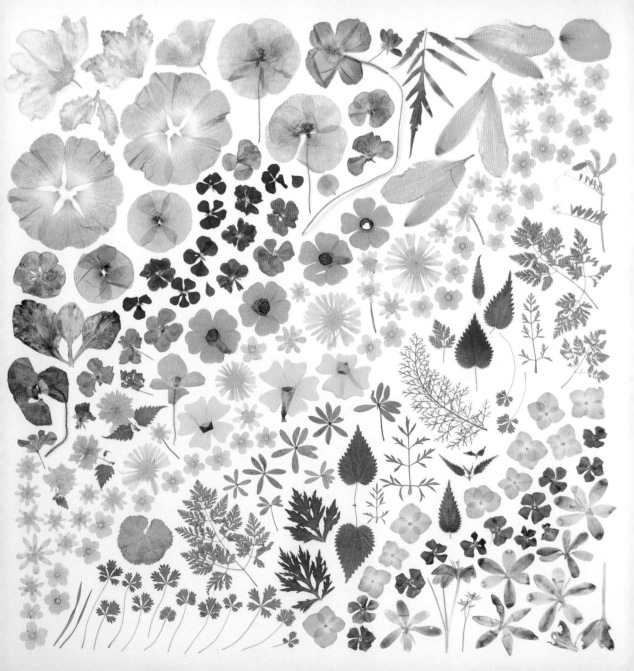

CRYSTALS

1 2 3 4 5 6 7 8 9 10 11 12 13

1. *Pink Rhodochrosite*
2. *Red Rhodochrosite*
3. *Hessonite Garnet*
4. *Scapolite*
5. *Apatite*
6. *Vesuvianite*
7. *Tourmaline*
8. *Fluorite*
9. *Dioptase*
10. *Aquamarine*
11. *Tanzanite*
12. *Amethyst*
13. *Spessartine Garnet*

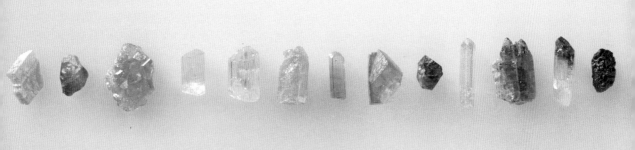

GEODES

1. *Cobaltoan Calcite from Souss-Massa-Drâa, Morocco*
2. *Crocoite from Tasmania, Australia*
3. *Citrine from Rio Grande do Sul, Brazil*
4. *Quartz from Iowa, United States*
5. *Sulfur from Mendoza, Bolivia*
6. *Malachite from Katanga Province, Democratic Republic of Congo*
7. *Fluorite from Durham, England*
8. *Celestine from Faritanin' i Mahajanga, Madagascar*
9. *Azurite from Hubei, China*
10. *Amethyst from Artigas, Uruguay*

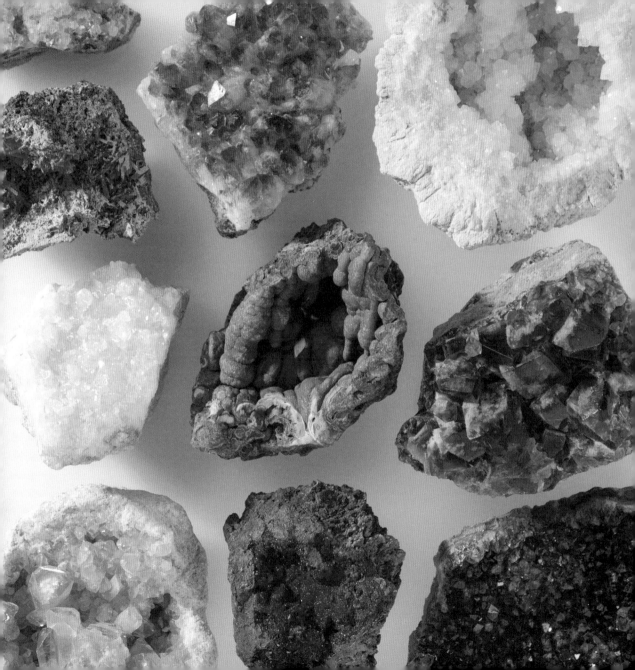

POLISHED STONES

1. *Pink Agate*
2. *Rose Quartz*
3. *Rhodochrosite*
4. *Red Jasper*
5. *Carnelian*
6. *Red Selenite*
7. *Orange Calcite*
8. *Yellow Jasper*
9. *Tiger's Eye*
10. *Serpentine*
11. *Prehnite*
12. *Epidote*
13. *Unakite*
14. *Fluorite*
15. *Aventurine*
16. *Jade*

17. *Nephrite*
18. *Malachite*
19. *Moss Agate*
20. *Heliotrope*
21. *Kambaba Jasper*
22. *Amazonite*
23. *Chrysocolla*
24. *Turquoise*
25. *Lapis Lazuli*
26. *Sodalite*
27. *Blue Lace Agate*
28. *Angelite*
29. *Lepidolite*
30. *Lavender Quartz*
31. *Amethyst*
32. *Mookaite Jasper*

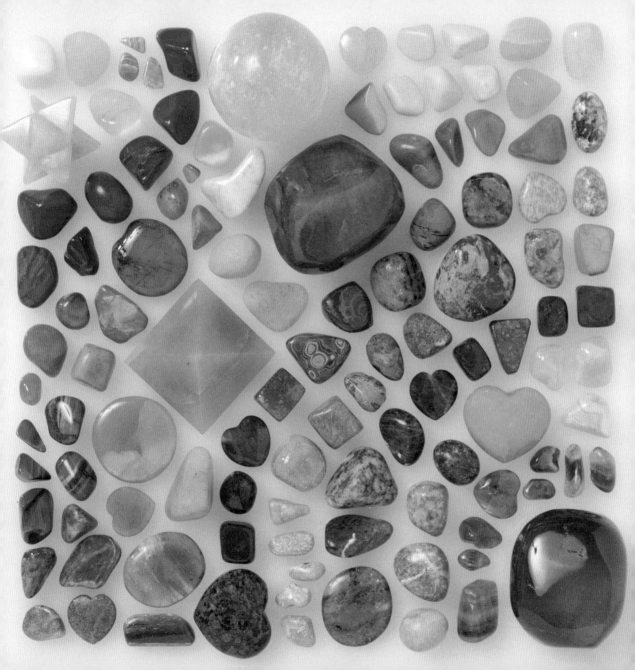

SEA GLASS

1. *Caribbean Sea, Puerto Rico*
2. *North Sea, Peterlee, England*
3. *Pacific Ocean, Washington, United States*
4. *North Sea, Seaham, England*
5. *Delaware River, New York, United States*
6. *Mediterranean Sea, Netanya, Israel*

7. *Caribbean Sea, Eleuthera, Bahamas*
8. *Pacific Northwest, United States*
9. *Pacific Ocean, California, United States*
10. *Tyrrhenian Sea, Capri, Italy*
11. *Atlantic Ocean, Galicia, Spain*
12. *Mediterranean Sea, Herzliya, Israel*
13. *Bering Sea, Alaska, United States*

14. *Aegean Sea, Athens, Greece*
15. *Pottery Shards, California, United States*
16. *Lake Superior, Michigan, United States*
17. *Atlantic Ocean, New Jersey, United States*
18. *Lake Erie, Ohio, United States*

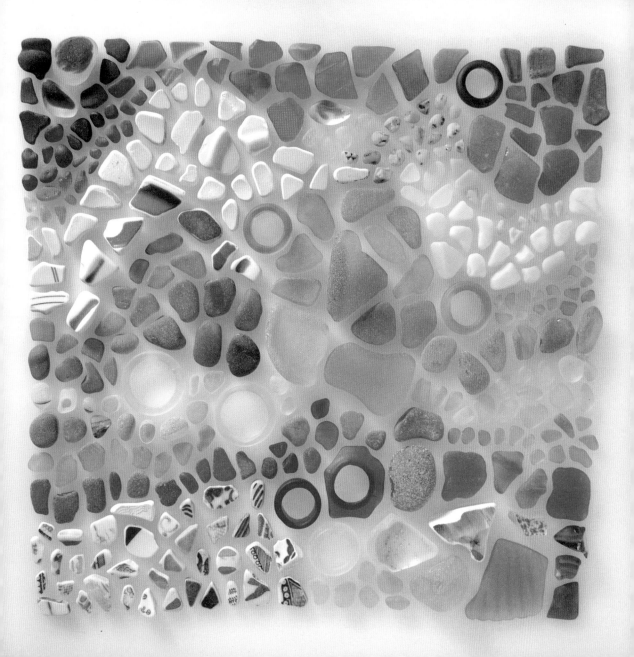

THE BUIL

T WORLD

PAINTING

1. *Cadmium Red Hue*
2. *Cadmium-Barium Red Light*
3. *Vermillion*
4. *Quinacridone Red*
5. *Permanent Alizarin Crimson*
6. *Cadmium-Barium Red Medium*
7. *Alizarin Crimson*
8. *Perylene Maroon*
9. *Cadmium Yellow Deep*
10. *Cadmium Orange*
11. *Cadmium Yellow*
12. *Naples Yellow Hue*
13. *Cadmium-Barium Yellow Medium*
14. *Cadmium Yellow Pale*
15. *Naples Yellow*
16. *Unbleached Titanium White*
17. *Raw Sienna*
18. *Yellow Ochre*
19. *Permanent Green Light*
20. *Phthalo Green (Yellow Shade)*
21. *Sap Green*
22. *Greenish Umber*
23. *Viridian Hue*
24. *Viridian*
25. *Phthalo Green (Blue Shade)*
26. *Cobalt Turquoise*
27. *Phthalo Blue*
28. *Indigo*
29. *Cerulean Blue*
30. *Prussian Blue*
31. *French Ultramarine Blue*
32. *Ultramarine Violet*
33. *Ultramarine Red*
34. *Thio Violet*

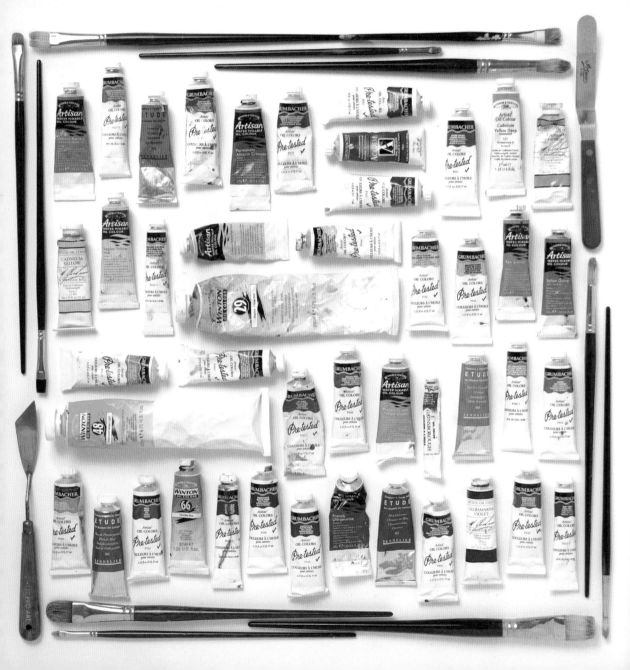

PASTELS

1. Carmine
2. Red Violet Light
3. Orange
4. Madder Carmine
5. Permanent Red Deep
6. Permanent Red Light
7. Deep Yellow
8. Gold Ochre
9. Raw Sienna
10. Light Yellow
11. Lemon Yellow
12. Yellow Ochre
13. Chrome Green Light
14. Permanent Green Light
15. Phthalo Green
16. Permanent Green Deep
17. Chrome Green Deep
18. Bluish Green
19. Prussian Blue
20. Ultramarine Deep
21. Red Violet Light
22. Blue Violet

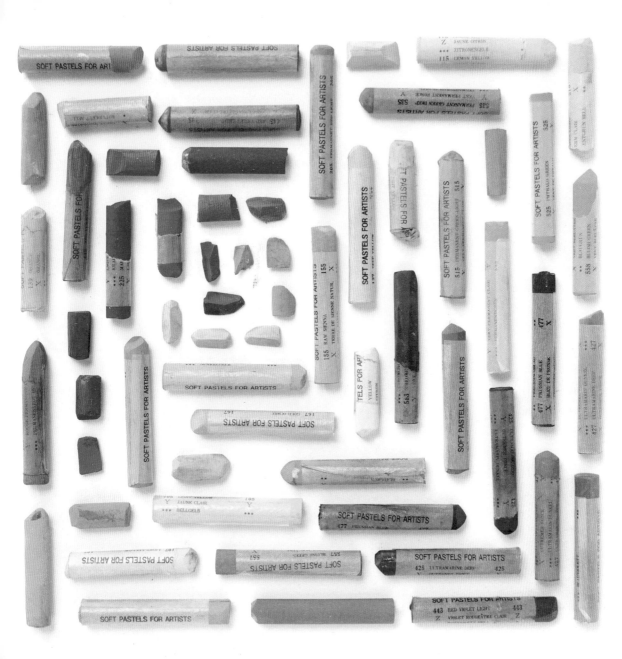

CERAMICS TOOLS

1. *Rib*
2. *Caliper*
3. *Bat Lifter*
4. *Art Roller*
5. *Pencil Sharpener*
6. *Knife*
7. *Fettling Tool*
8. *Underglaze Pencil*
9. *Sponge-on-a-Stick*
10. *Square Hole Cutter*
11. *Round Hole Cutter*
12. *Texture Wheel*
13. *Bat*
14. *Double-Ended Carving Tools*
15. *Texture Combs*
16. *Scalpel*
17. *Brushes*
18. *Turning Tool*
19. *Clay Hammer*
20. *Modeling Tools*
21. *Trimming Tool*
22. *Ceramic Bowl*
23. *Glaze*

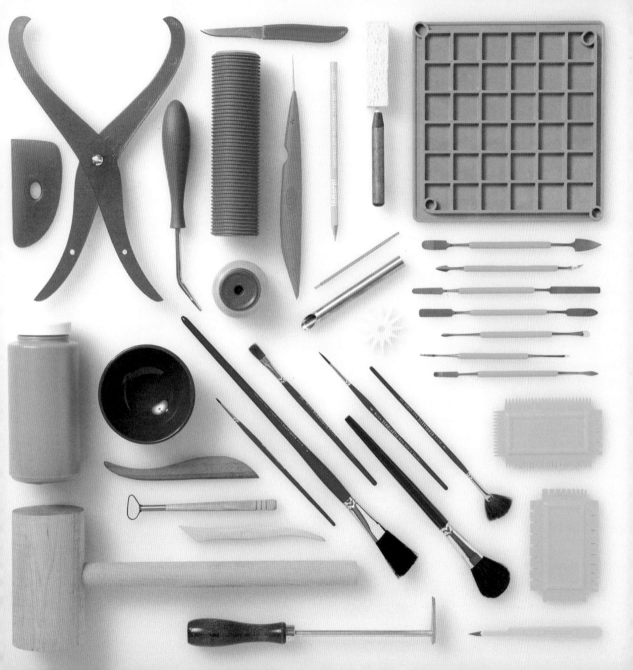

LITERATURE

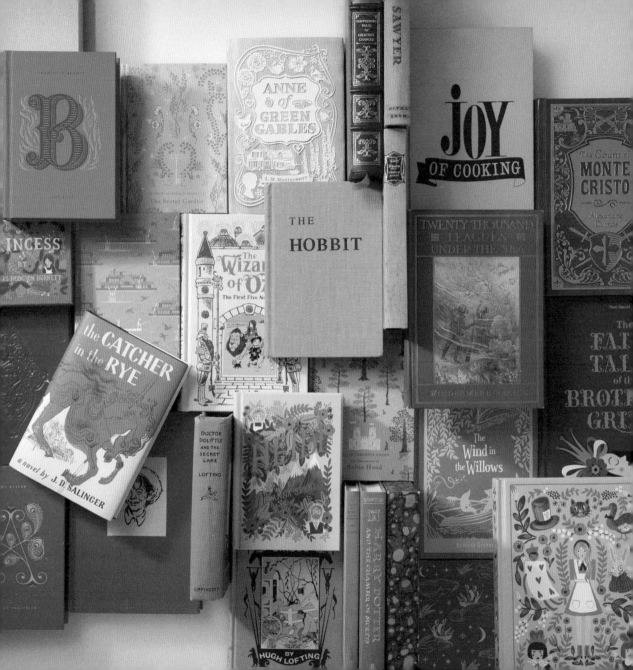

SEWING

1. *Fabric Pencil*
2. *Silk Thread*
3. *Quilting Thread*
4. *Seam Ripper*
5. *Pin Cushion with Emery*
6. *Cotton Thread*
7. *Polyester Thread*
8. *Poly/Cotton Thread*
9. *Sewing Thread*
10. *Thimble*
11. *Embroidery Scissors*
12. *Synthetic Thread*
13. *Nylon Thread*
14. *Straight Pins*

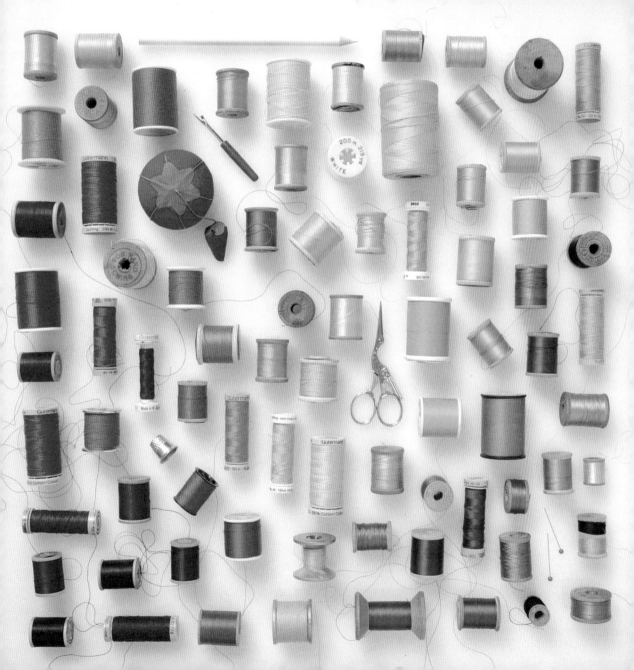

QUILT BLOCKS

1	2	3	4
5	6	7	8
9	10	11	12
13	14	15	16

1. *Flower Basket*
2. *Schoolhouse*
3. *Rocky Road to California*
4. *Autumn Leaf*
5. *Pineapple Appliqué*
6. *Shoofly*
7. *Ohio Star*
8. *Independence Square*
9. *Hill and Valley*
10. *Pine Tree*
11. *Daffodil*
12. *Log Cabin*
13. *Bear Paw*
14. *Storm at Sea*
15. *Flying Geese*
16. *Prairie Queen*

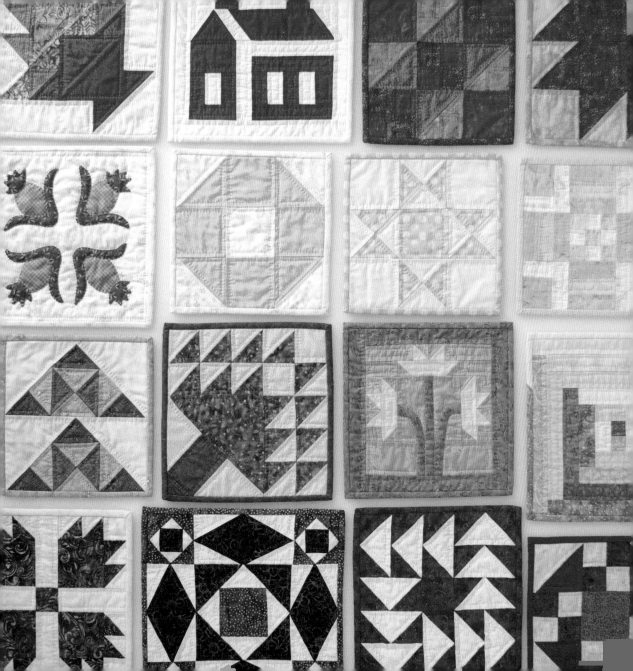

ORIGAMI

1. *Lobster*
2. *Ladybug*
3. *Lotus Flowers*
4. *Flowers*
5. *Bird in Flight*
6. *Crane*
7. *Hats*

8. *Tulip*
9. *Goldfish*
10. *Lilies*
11. *Sitting Dog*
12. *Ninja Star*
13. *Swan*
14. *Butterflies*

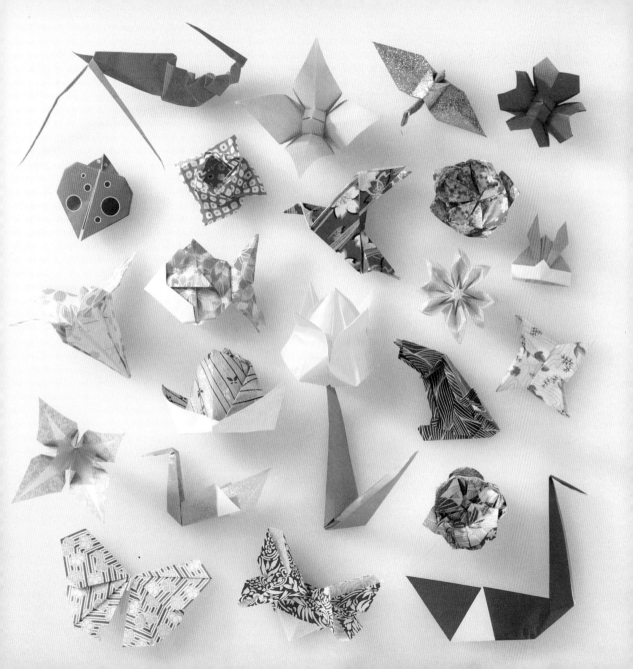

KNITTING

1. *French Angora Yarn*
2. *Acrylic Yarn*
3. *Cotton Yarn*
4. *Alpaca Yarn*
5. *Linen Yarn*
6. *Bamboo Yarn*
7. *Silk Yarn*
8. *Shetland Wool Yarn*
9. *Cashmere Yarn*
10. *Yak Yarn*
11. *Mohair Yarn*
12. *Size 4 Double-Pointed Needles*
13. *Crochet Hook*
14. *Size 8 Needles*

15. *Bird's Wing Cable Needle*
16. *Size 11 Needles*
17. *Large Eye Needle*
18. *Size 6 Needles*
19. *Stitch Holder*
20. *Size 13 Needles*
21. *Size 7 Needles*
22. *Circular Needles*
23. *J-Hook Cable Needle*
24. *Row Counter*
25. *Size 50 Needle*
26. *Size 35 Needle*
27. *Stitch Marker*
28. *Size 9 Double-Pointed Needles*

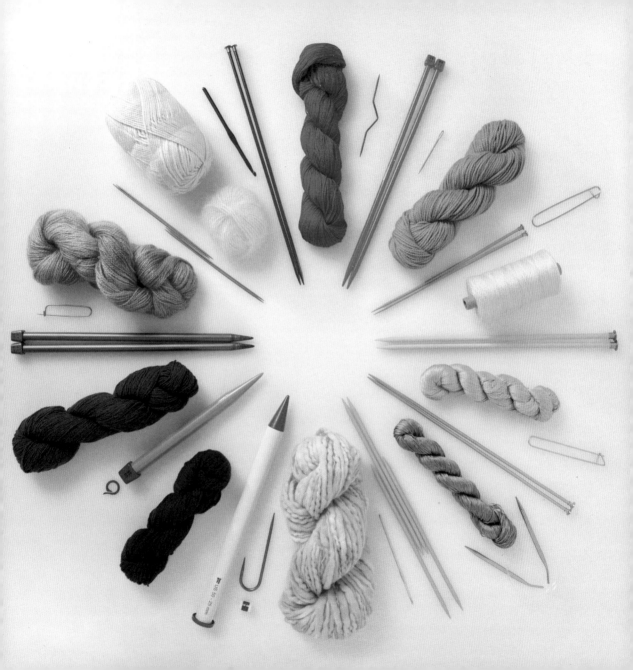

LEIS

1. *Mauna Loa–Style Orchid*
2. *Micronesian-Style Ginger*
3. *Double Twist Orchid*
4. *Single String Ohai Ali'i*
5. *Double String Plumeria*
6. *Single String Orchid*
7. *Triple Rope-Style Orchid*
8. *Rope-Style Orchid*

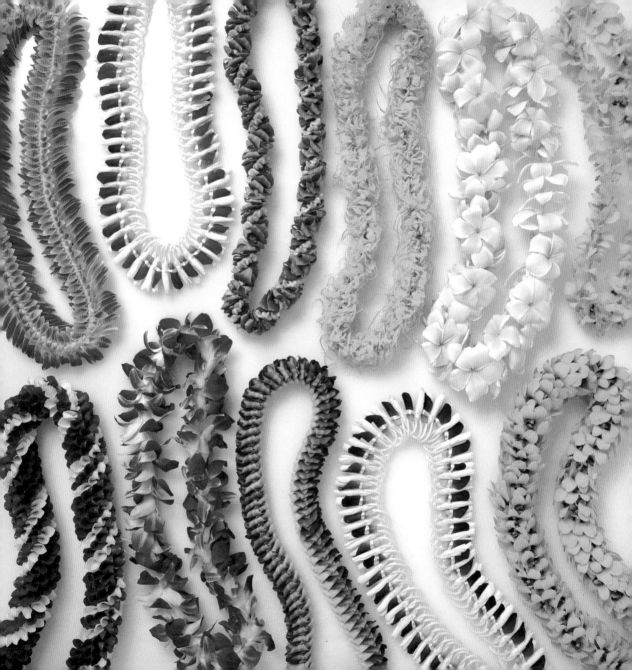

BEAUTY & MAKEUP

1. *Eye Brightener*
2. *Mascara*
3. *Nail Polish*
4. *Lip and Cheek Cream*
5. *Lip Scrub*
6. *Blending Sponge*
7. *Blush*
8. *Lip Balm*
9. *Lip Treatment*
10. *Liner Brush*
11. *Lip Gloss*
12. *Lip Liner*
13. *Lipstick*
14. *Eye Shadow*
15. *Eye Liner*
16. *Lip Plumper*
17. *Kabuki Brush*
18. *Fan Brush*
19. *Eye Shadow Stick*
20. *Compact*
21. *Foundation Brush*
22. *Primer Powder*
23. *Eyelash Curler*
24. *Brow Brush*

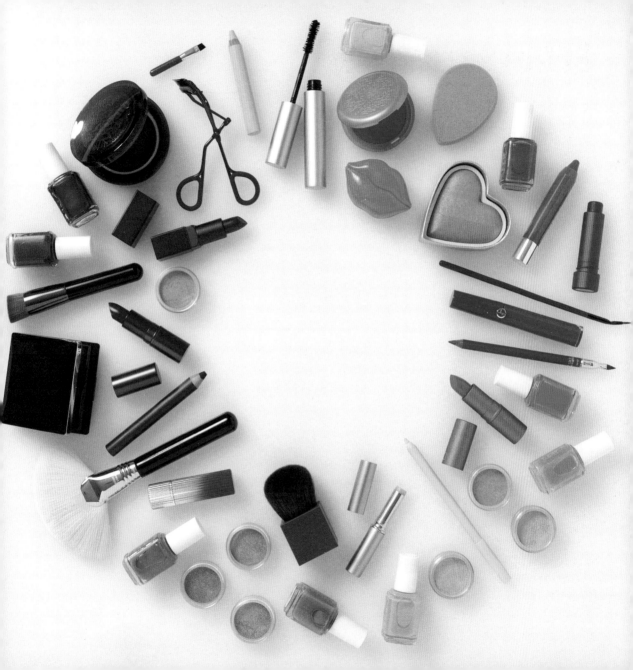

LIGHT BULBS

1. *Transparent Sign Light*
2. *Torpedo Candelabra Bulb*
3. *Garden Lights*
4. *Infrared Heat Lamp*
5. *Red LED Party Light*
6. *Incandescent Party Light*
7. *LED Wet Location Light*
8. *Bubble Light*
9. *Opaque Sign Light*
10. *Retro Christmas Tree Light*
11. *Auto Indicator Bulb*
12. *Wrinkled-Flame Glass Bulb*
13. *Bent Tip Bulb*
14. *CFL Party Light*
15. *Satin String Light*
16. *Filament Bulb*
17. *Ice Globe Bulb*
18. *CFL Bug Light*
19. *Opaque Marquee Light*
20. *Incandescent Bug Light*
21. *Waterproof Flood Light*
22. *LED Candelabra Light*
23. *Long Neck Reflector*
24. *Emergency Flasher*
25. *Halogen Fog Lamp*
26. *Globe Bulb*
27. *Plant Light*
28. *Purple LED Party Light*
29. *Faceted Christmas Tree Light*
30. *Exotic Pet Light*
31. *Daylight Bulb*
32. *Picture Frame Light*
33. *Frosted Globe Bulb*
34. *Fluorescent Black Light*
35. *1000 Watt*

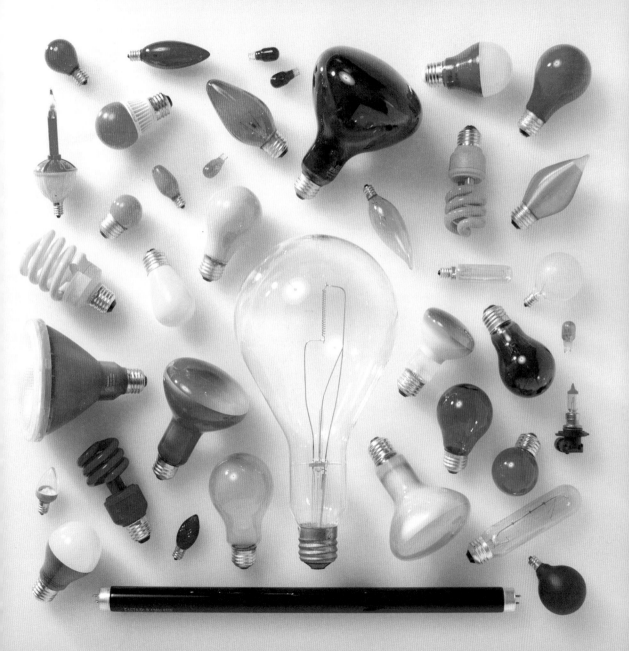

TELEPHONES

1. *Prism Phone*
2. *Princess Phone*
3. *Lips Phone*
4. *No-Dial Wall Phone*
5. *Rotary Dial Wall Phone*
6. *Lineman Test Phone*
7. *Sculptura Phone*
8. *Banana Phone*
9. *Dawn "Pancake" Rotary Dial Phone*
10. *Push-Button Desk Phone*
11. *Rotary Dial Desk Phone*
12. *Retro Pop Phone Handset and iPhone 6*
13. *Pay Phone*
14. *Twin Phone*
15. *Conairphone*

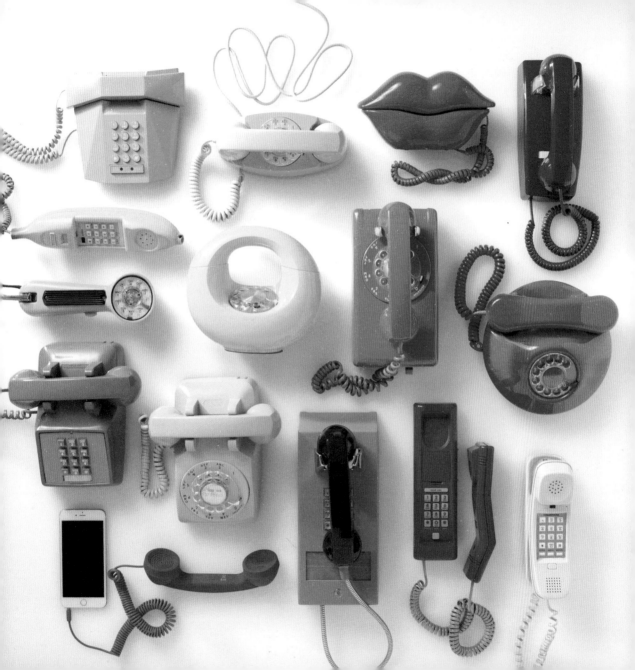

MEDICAL TOOLS

1. *Stethoscope*
2. *Syringe with Needle*
3. *Diphenhydramine, allergy relief*
4. *Reflex Hammer*
5. *Invalid Ring*
6. *Tourniquet*
7. *CPR Mask*
8. *Acetaminophen*
9. *Pseudoephedrine*
10. *Drawing Salve*
11. *Alcohol Prep Pads*
12. *Splint*
13. *Ibuprofen*
14. *Zinc*
15. *Oral Syringe*
16. *Pupil Gauge Light*

17. *Medicine Dropper*
18. *Athletic Tape*
19. *Dressing Scissors*
20. *Adhesive Bandages*
21. *Dextromethorphan*
22. *Cetirizine*
23. *Pill Case*
24. *Oxygen Regulator*
25. *Surgical Tape*
26. *Diphenhydramine, sleep aid*
27. *Manual Resuscitator*
28. *Thermometer*
29. *Finger Splint*
30. *Blood Pressure Cuff*
31. *Bandage Tape*

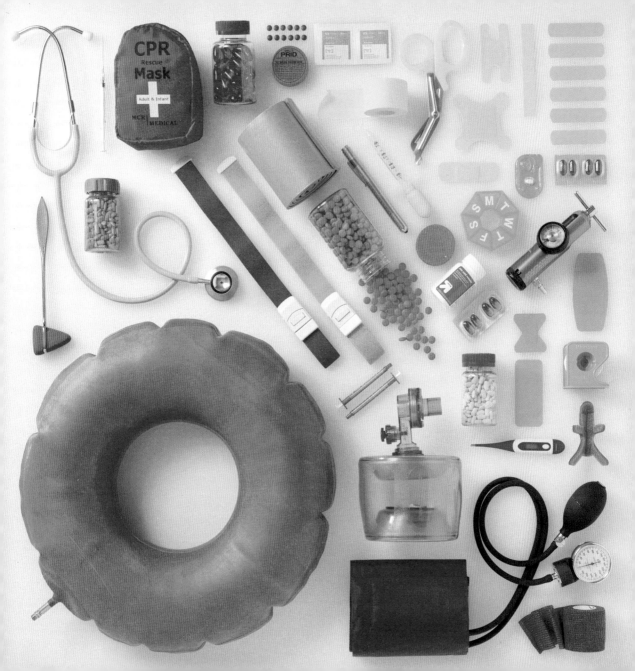

TOY TRAINS

1. *Caboose*
2. *Boxcar*
3. *Cattle Car*
4. *Crane Car*
5. *Chemical Tank Car*
6. *Work Caboose*
7. *Barrel Car*
8. *Refrigerator Car*
9. *Generator Car*
10. *Tender*
11. *Switcher Locomotive*

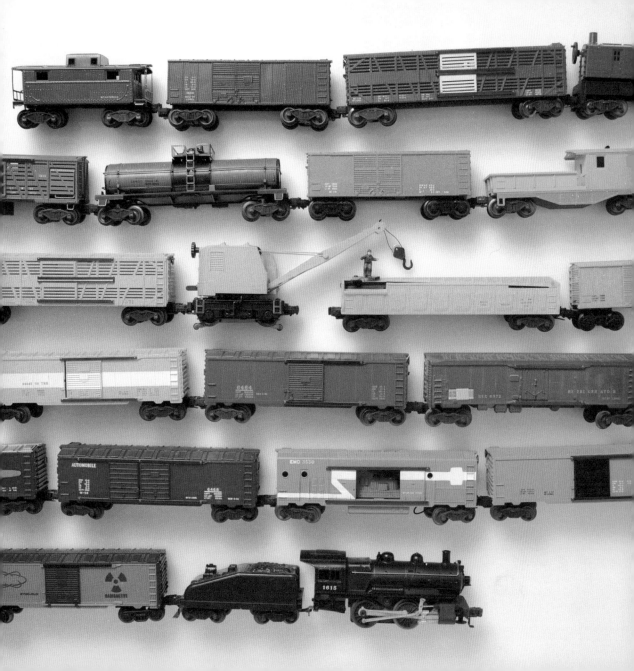

TOY CARS

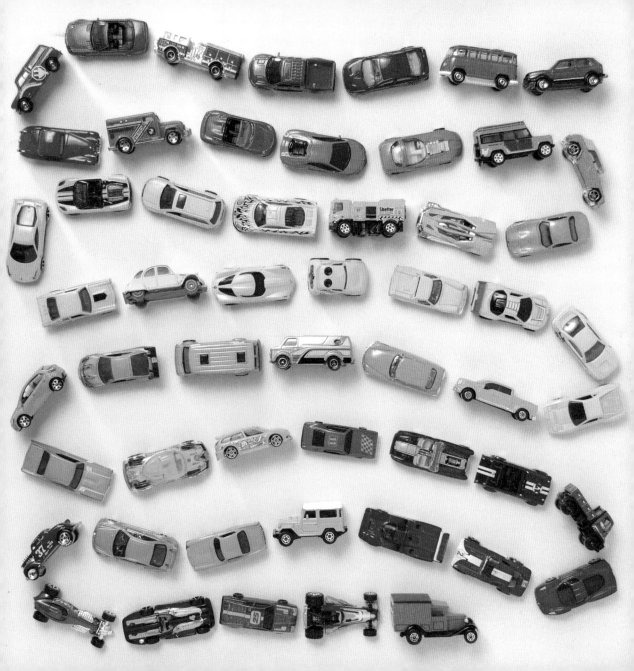

TOY VANS

1. *First Generation Panel Delivery Van*
2. *First Generation Microbus Standard*
3. *First Generation Double Door Panel Delivery Van*
4. *First Generation Deluxe Microbus with Twenty-Three Windows*
5. *First Generation Rescue Kombi*
6. *First Generation Microbus*
7. *Second Generation Right-Hand Drive Camper*
8. *Vanagon Camper*
9. *Second Generation Camper*
10. *Second Generation Microbus*
11. *First Generation Deluxe Microbus with Camper*
12. *First Generation Deluxe Microbus with Twenty-One Windows*
13. *First Generation Kombi*
14. *First Generation Right-Hand Drive Panel Delivery Van*
15. *First Generation Deluxe Microbus with Open Sunroof*
16. *First Generation Single Cabin Pickup Truck*
17. *Second Generation Microbus with Surfboards*

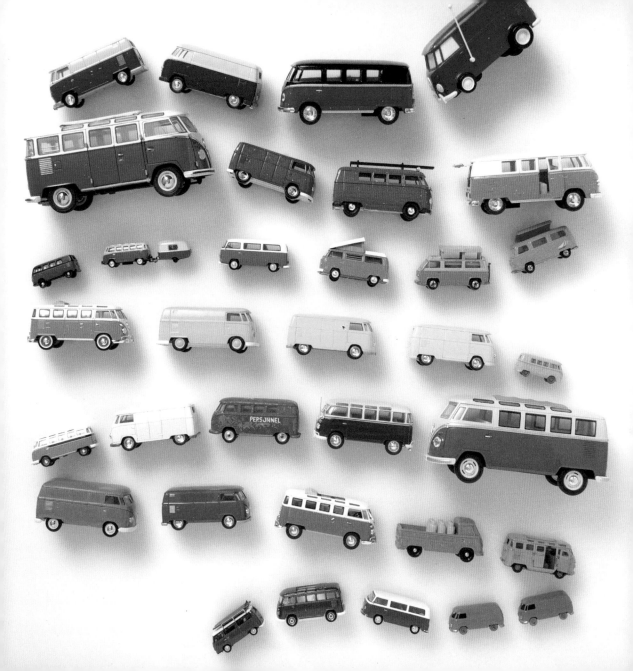

LICENSE PLATES

1. *New Mexico, 1959*
2. *Indiana, 1954*
3. *South Dakota, 1953*
4. *Missouri, 1955*
5. *New Mexico, 1953*
6. *Ohio, 1959*
7. *Newfoundland, 1953*
8. *New Mexico, 1954*
9. *Utah, 1959*
10. *Panama, 1953*
11. *Iran, 1954*
12. *Florida, 1953*
13. *Maryland, 1955*
14. *North Carolina, 1954*
15. *California, 1956*
16. *Texas, 1953*
17. *Pennsylvania, 1953*
18. *Kansas, 1959*
19. *Maine, 1959*

20. *Alaska, 1959*
21. *Colorado, 1953*
22. *Prince Edward Island, 1953*
23. *Louisiana, 1954*
24. *Alaska, 1953*
25. *Iowa, 1959*
26. *Manitoba, 1953*
27. *U.S. Virgin Islands, 1953*
28. *Philippines, 1953*
29. *Nevada, 1953*
30. *Illinois, 1954*
31. *Colorado, 1959*
32. *North Dakota, 1953*
33. *Washington, 1954*
34. *New Hampshire, 1953*
35. *Ohio, 1953*
36. *Utah, 1954*
37. *Idaho, 1959*
38. *Washington, 1959*

39. *Arkansas, 1954*
40. *South Carolina, 1959*
41. *Louisiana, 1953*
42. *District of Columbia, 1960*
43. *Monaco, 1953*
44. *Yukon Territory, 1953*
45. *Alabama, 1959*
46. *Maryland, 1960*
47. *Netherlands, 1953*
48. *Ontario, 1953*
49. *Florida, 1954*
50. *Michigan, 1954*
51. *Kansas, 1953*
52. *Oregon, 1959*
53. *Missouri, 1954*
54. *Ohio, 1954*
55. *Massachusetts, 1959*

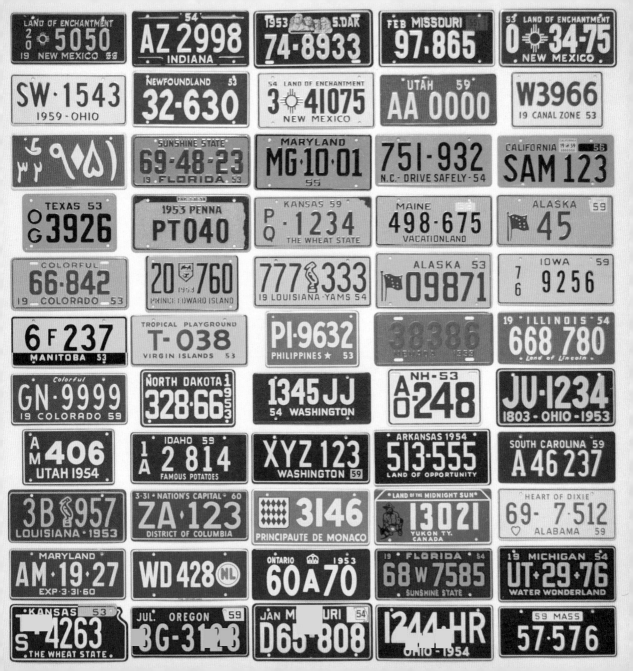

PASTA

1. *Linguini with Red Chili*
2. *Penne with Tomato and Carrots*
3. *Farfalle with Beetroot*
4. *Zucchette with Paprika*
5. *Orecchiette with Turmeric*
6. *Tagliatelle with Porcini Mushrooms*
7. *Linguine with Lemon and Black Pepper*
8. *Rotelle*
9. *Egg Pappardelle*
10. *Pici*
11. *Spaghetti*
12. *Strozzapreti*
13. *Gnocchi*
14. *Linguine with Garlic and Basil*
15. *Olive Leaves with Spinach*
16. *Orecchiette with Spinach*
17. *Fusilli with Spinach*
18. *Penne with Spinach*
19. *Farfalle with Spirulina Seaweed*
20. *Linguine Zebra Colored with Squid Ink*
21. *Penne with Cacao*
22. *Elbows with Sprouted Whole Wheat*

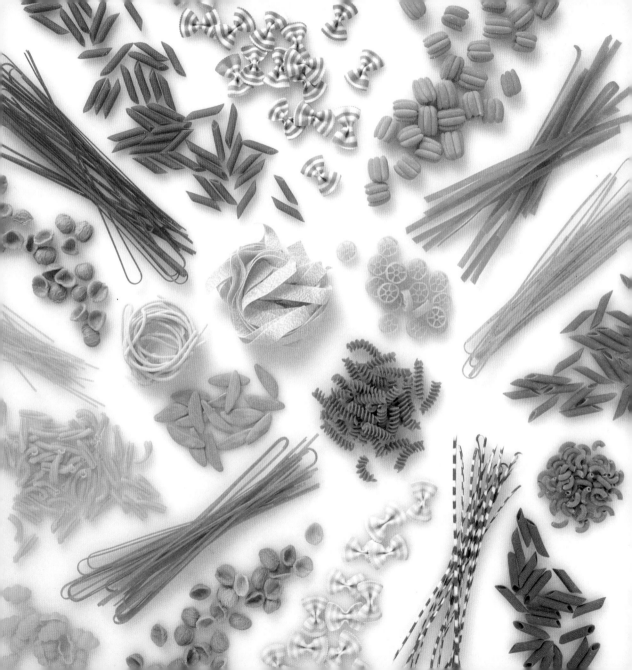

DRIED FRUITS

1. *Cranberries*
2. *Strawberries*
3. *Hibiscus*
4. *Cherries*
5. *Peaches*
6. *Mango*
7. *Oranges*
8. *Apricots*
9. *Pears*
10. *Cantaloupe*
11. *Pineapple*
12. *Ginger*
13. *Kiwi*
14. *Pomelo*
15. *Blueberries*
16. *Prunes*

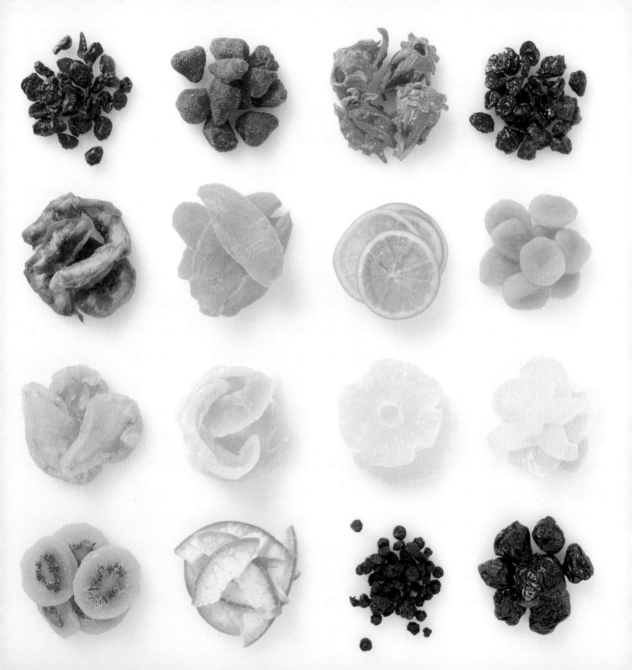

CHEESES

1. *Red Wax Gouda, Cow Milk, Wisconsin, United States*

2. *Red Dragon Cheese with Mustard Seed and Ale, Cow Milk, Wales*

3. *Port Salut, Cow Milk, Loire Valley, Brittany, France*

4. *Pavé du Nord, Cow Milk, Northern France*

5. *Boerenkaas Gouda, Cow Milk, Netherlands*

6. *Cotswold, Cow Milk, Glouchestershire County, England*

7. *Jarlsberg, Cow Milk, Jarlsberg, Norway*

8. *Sage Derby, Cow Milk, Derbyshire, England*

9. *Fromager d'Affinois with Garlic and Herbs, Cow Milk, Rhône-Alpes, France*

10. *Kerrygold Dubliner with Irish Stout, Cow Milk, County Cork, Ireland*

11. *Pecorino Toscano Fresco D. O. P., Sheep Milk, Tuscany, Italy*

12. *Cashel Blue, Cow Milk, County Tipperary, Ireland*

13. *Blue Stilton, Cow Milk, Derbyshire, England*

14. *Reserve Cheese with Merlot, Cow Milk, Wisconsin, United States*

15. *Wensleydale and Cranberries, Cow Milk, Wensleydale, North Yorkshire, England*

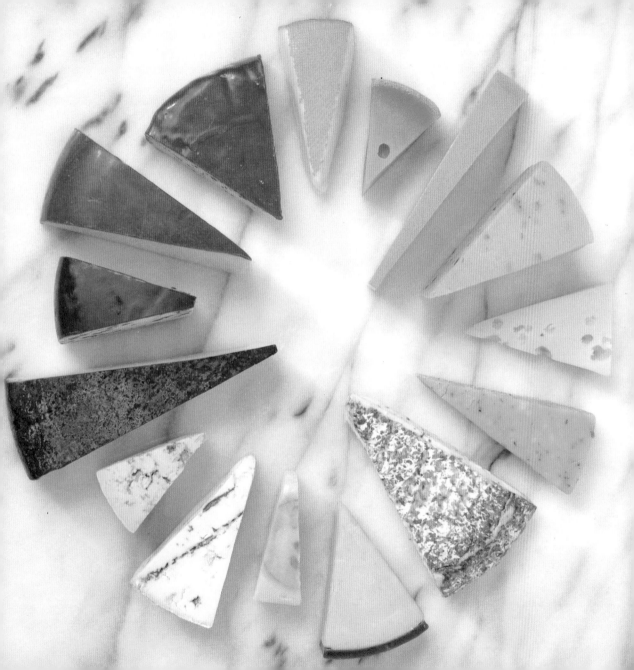

ANTIPASTI

1. *Mortadella*
2. *Prosciutto*
3. *Roasted Red Peppers*
4. *Cherry Tomatoes*
5. *Breadsticks*
6. *Parmesan Cheese*
7. *Mozzarella with Basil*
8. *Castelvetrano Olives*
9. *Kalamata Olives*

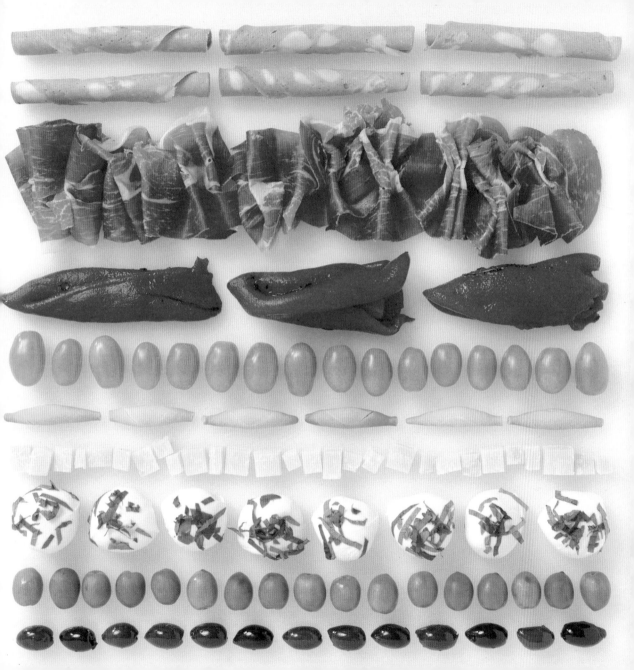

SPICES & SALTS

1	2	3	4	5	6	7
8	9	10	11	12	13	14
15	16	17	18	19	20	21
22	23	24	25	26	27	28
29	30	31	32	33	34	35
			36			
			37			
			38			

1. *Himalayan Pink Salt, Fine*
2. *Himalayan Pink Salt, Coarse*
3. *Hawaiian Pink Salt*
4. *Alaea Salt*
5. *Pink Peppercorns*
6. *Pequin Chilies*
7. *Saffron*
8. *Chipotle Chile*
9. *Red Bell Pepper Flakes*
10. *Paprika*
11. *Red Chile Flakes*
12. *Cayenne*
13. *Tandoori Masala*
14. *Cinnamon*
15. *Turmeric*
16. *Mustard*
17. *Minced Onion*
18. *Garlic Powder*
19. *Crystallized Ginger*
20. *Ground Ginger*
21. *Yellow Mustard Seeds*
22. *Fennel Seed*
23. *Rosemary*
24. *Whole Cardamom*
25. *Bay Leaves*
26. *Tarragon*
27. *Chives*
28. *Dill*
29. *Juniper Berries*
30. *Poppy Seeds*
31. *Lavender*
32. *Merlot Sea Salt*
33. *Black Peppercorns*
34. *Whole Cloves*
35. *Ground Clove*
36. *Nutmegs*
37. *Cinnamon Sticks*
38. *Vanilla Beans*

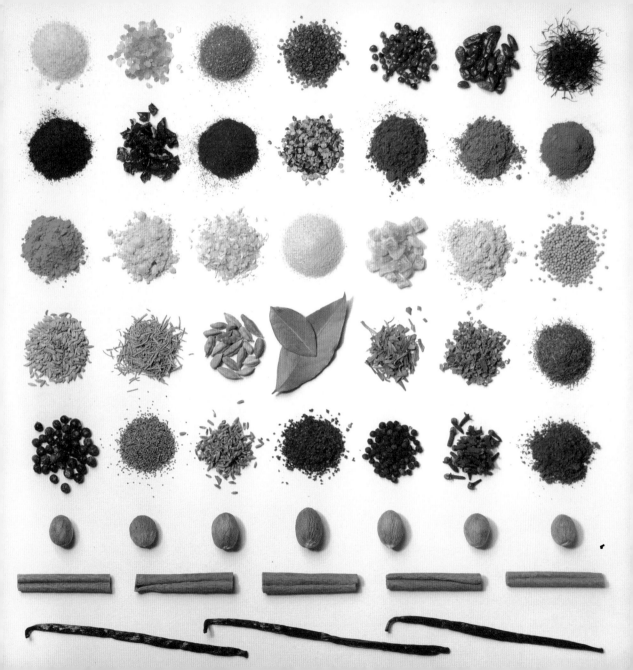

SEED PACKETS

1	2	3	4	5	6	7	8
9	10	11	12	13	14	15	16
17	18	19	20	21	22	23	24
25	26	27	28	29	30	31	32
33	34	35	36	37	38	39	40

1. *Radish*
2. *Kudzu Vine*
3. *Carnation*
4. *Crosby's Egyptian Beet*
5. *Garden State Tomato*
6. *Schoon's Hard Shell Muskmelon*
7. *Coreopsis*
8. *Top Notch Golden Wax Beans*
9. *Phlox*
10. *Heart of France Aster*
11. *King of the North Pepper*
12. *Chinese Lantern Plant*
13. *California Poppy*
14. *Bantam Evergreen Hybrid Corn*
15. *Large Cheese Pumpkin*
16. *Wisconsin Hollander No. 8 Cabbage*
17. *Trucker's Early Money Radish*
18. *Grothen's Globe Tomato*
19. *Edisto Muskmelon*
20. *Chantenay Carrot*

21. *Pencil Pod Black Wax Beans*
22. *Early Knight Muskmelon*
23. *Marion Market Cabbage*
24. *Anchusa Capensis Blue Bird*
25. *Nasturtium*
26. *Yellow Plum Tomato*
27. *Cherokee Wax Beans*
28. *Green Striped Cushaw Pumpkin*
29. *Challenger Pole Lima Beans*
30. *Nobel Spinach*
31. *Heavenly Blue Petunia*
32. *Blue Gem Aster*
33. *Fordhook Muskmelon*
34. *Calendula*
35. *Celery*
36. *Dwarf White Sugar Peas*
37. *Cocozelle Squash*
38. *Heavenly Blue Morning Glory*
39. *Matthiola Evening-Scented Stocks*
40. *American Purple Top Rutabaga*

ALES & BEERS

1. *Molson Ale*
2. *Michelob Beer*
3. *Carling Black Label Beer*
4. *MacEwan's Strong Ale*
5. *O'Keefe Ale*
6. *Budweiser Lager Beer*
7. *Cinci Lager Beer*
8. *Mustang Malt Liquor*
9. *Tecate Cerveza*
10. *Billy Beer*
11. *Brickskeller Saloon Style Lager*
12. *Olympia Beer*
13. *MacEwan's Scotch Ale*
14. *Crystall Wührer Birra Speciale*
15. *Andeker Beer*
16. *Olympia Gold Light Beer*
17. *Buckhorn Lager*
18. *Gluek Pilsner Beer*
19. *Utica Club Pilsener Lager Beer*
20. *Ballantine XXX Ale*
21. *Columbia Pale Beer*
22. *Carlsberg Lager Beer*
23. *Labatt 50 Light Ale*
24. *Carling Red Cap Ale*
25. *Pearl Cream Ale*
26. *Gemeinde Brau*
27. *Arrowhead Beer*
28. *Schmidt's Bavarian Beer*
29. *Pabst Light Beer*
30. *Schlitz Malt Liquor*
31. *Fischer's Old German Style Beer*
32. *Labatt Pilsner Beer*
33. *Laurentide Ale*
34. *Foster's Lager*
35. *Gambrinus Gold Beer*

TEA

1. *White Rose Tea, Yunnan Province, China*
2. *Bone China Teapot, England*
3. *Enamelware Teapot, England*
4. *Rooibos Tea, South Africa*
5. *Yixing Teapot, China*
6. *Chai Tea, India*
7. *Kyusu Teapot, Japan*
8. *Teapot, United States*
9. *Linden Tea, Greece*
10. *Chamomile Tea, Croatia*
11. *Teapot, California, United States*
12. *Chrysanthemum Tea, Zhejiang, China*
13. *Teapot, England*
14. *Matcha Tea, Japan*
15. *Bamboo Chasen, Japan*
16. *Sencha Green Tea, Shizuoka, Japan*
17. *Darjeeling Tea, West Bengal, India*
18. *Teacup, United States*
19. *Gzhel Teapot, Russia*
20. *Cast Iron Teapot, Japan*
21. *Earl Gray Tea, Sri Lanka*

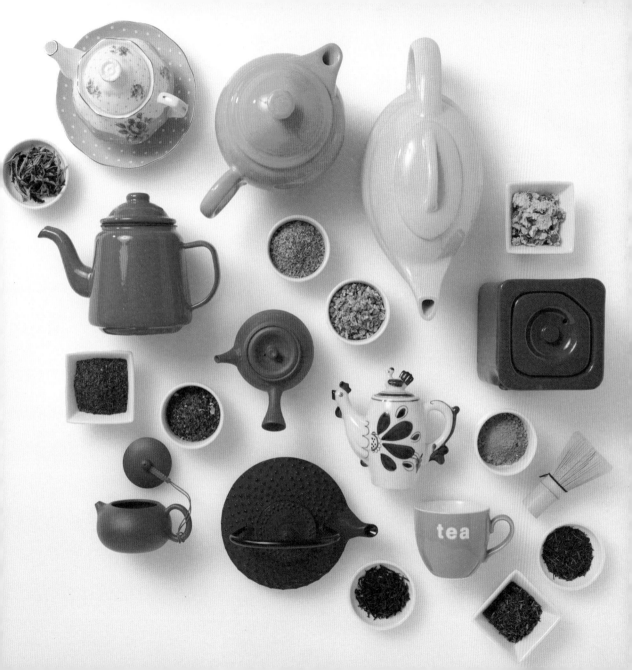

SOFT DRINKS

1. *Fentimans Rose Lemonade*
2. *Frostie Strawberry Watermelon*
3. *Salvavidas Strawberry*
4. *Big Red Cream Soda*
5. *Howdy Cherry Jubilee*
6. *Nehi Peach*
7. *Orange Crush*
8. *Bedford's Orange Creme*
9. *Orange Fanta*
10. *Stewart's Orange 'n Cream*
11. *Tropical Banana*
12. *Tiky Pineapple*
13. *Goody Pineapple and Nectarine*
14. *Mundet Green Apple*
15. *Bubble Up Lemon Lime*
16. *Jarritos Grapefruit*
17. *7-Up Lemon Lime*
18. *Fresca Grapefruit*
19. *Squirt Citrus*
20. *Jic Jac Blue Raspberry*
21. *Goody Raspberry and Cream*
22. *Fitz's Cream Soda*
23. *Maine Root Blueberry*
24. *Boylan Bottling Company, Grape*
25. *Olde Brooklyn Black Cherry*

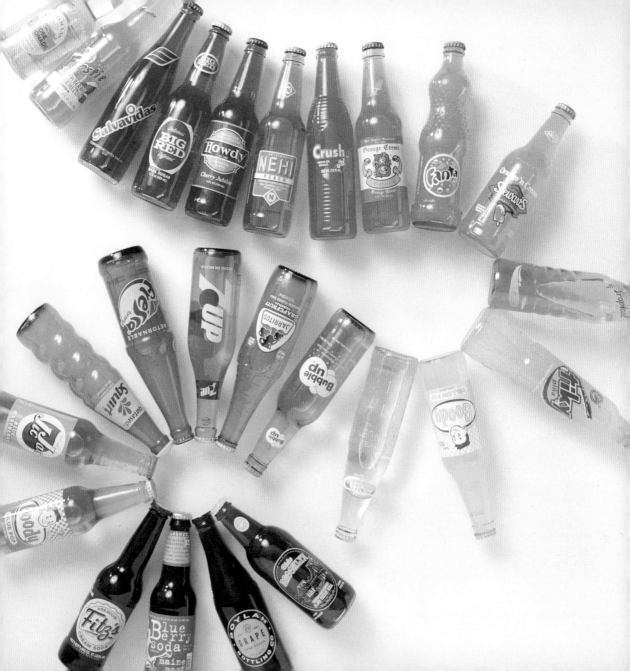

CEREAL

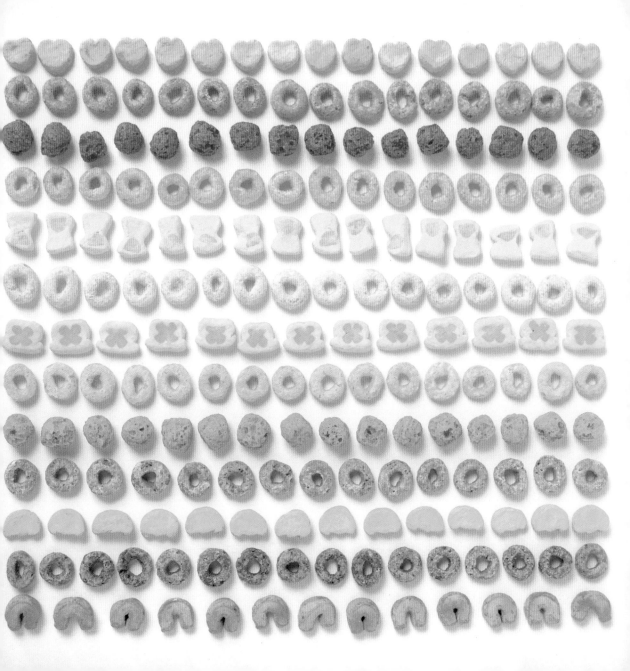

DONUTS

1. *Cherry Glaze with Cream Cheese Drizzle*

2. *Bubblegum Glaze with Pink Sprinkles*

3. *Cherry Blossom Glaze with Pastel Sugar Flakes*

4. *Pear Glaze with Apple Candy Sprinkles*

5. *Rosewater Glaze with White Sugar Pearls*

6. *Orange Glaze with Orange Sherbert Candy Sprinkles*

7. *Banana Glaze with Pink and White Sprinkles*

8. *Mojito Glaze with Lime Drizzle*

9. *Mango Glaze with Citrus Drizzle*

10. *Mint Glaze with Jumbo Confetti Sprinkles*

11. *Blue Cotton Candy with Marshmallow Drizzle*

12. *Blueberry Glaze with White Nonpareils*

13. *Limoncello Glaze with Yellow Nonpareils*

14. *Matcha Green Tea Glaze with Vanilla Drizzle*

15. *Blue Raspberry Glaze with White Sugar Pearls*

16. *Blackberry Glaze with Ginger Drizzle*

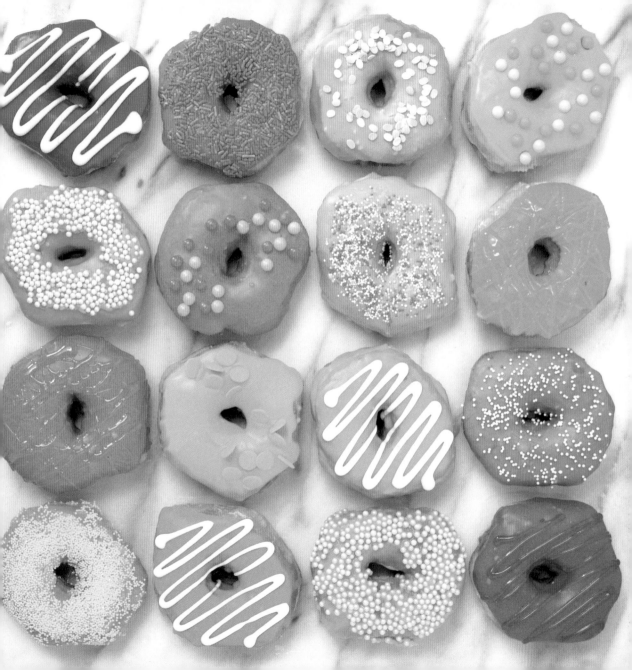

MACARONS

1. Vanilla Rose
2. Cherry Zinfandel
3. Almond
4. Rose
5. Chocolate Strawberry
6. Fig Walnut
7. Raspberry
8. Strawberry
9. Red Velvet Ganache
10. Pomme d'Amore
11. Raspberry
12. White Chocolate Peppermint
13. Red Velvet
14. Brown Butter
15. Orange Creamsicle
16. Orange Blossom

17. Peanut Butter Cup
18. Passion Fruit
19. Pumpkin Cinnamon
20. Chocolate Orange
21. Chestnut
22. Lemon
23. Crème Brûlée
24. Champagne
25. Passion Fruit Curd
26. Sicilian Pistachio
27. Pistachio
28. Key Lime Chocolate
29. Key Lime Pie
30. Matcha Green Tea
31. Fruity Cereal
32. Peanut Butter and Jelly

33. Coconut
34. Peppermint Mocha
35. Earl Grey
36. White Chocolate
37. Cotton Candy
38. Violet Cassis
39. Cocoa Nib
40. Salted Caramel
41. Cassis
42. Honey Lavender
43. Grape Soda
44. Birthday Cake
45. Chocolate
46. Chocolate Raspberry
47. Raspberry and Apricot

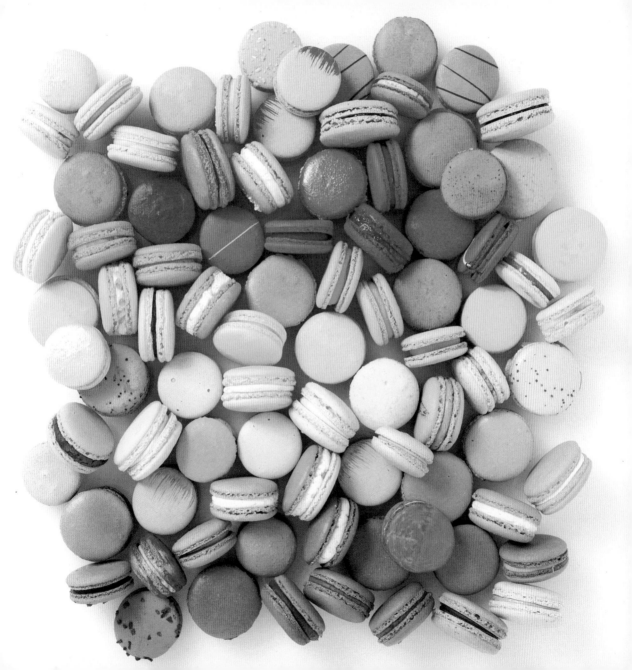

POPCORN

1. *Strawberry*
2. *Cinnamon*
3. *Cheddar Cheese*
4. *Butter*
5. *Mint Cookie*
6. *Vanilla Butter Mint*
7. *Blueberry*
8. *Lavender Marshmallow*
9. *Peanut Butter and Jelly*

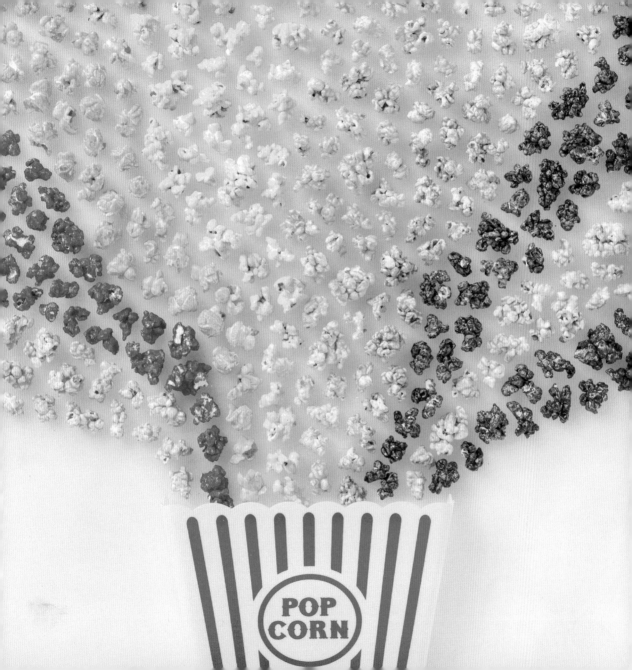

TAFFY

1
2
3
4
5
6
7
8
9
10
11
12
13
14

1. *Frosted Cupcake*
2. *Strawberry*
3. *Candy Apple*
4. *Cinnamon*
5. *Passion Fruit*
6. *Oranges and Cream*
7. *Lemon*

8. *Banana*
9. *Watermelon*
10. *Key Lime*
11. *Blueberry*
12. *Sour Grape*
13. *Grape*
14. *Huckleberry*

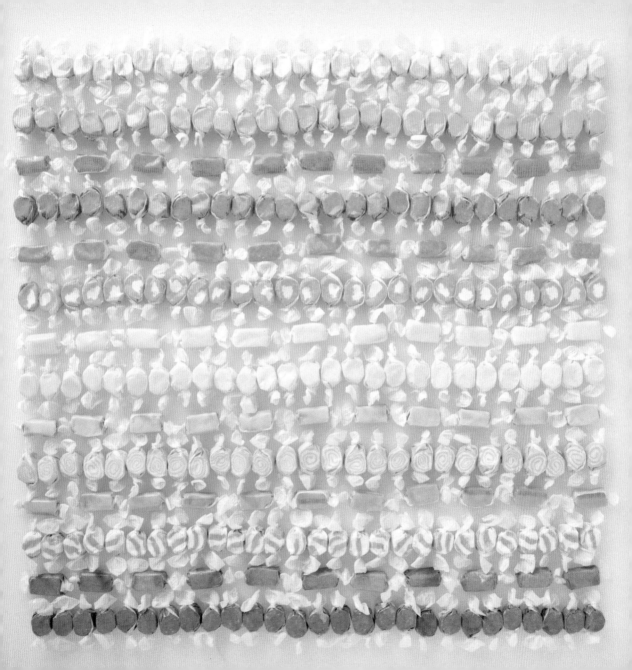

JELLY BEANS

1. *Bubblegum*
2. *Cotton Candy*
3. *Strawberry Daiquiri*
4. *Raspberry*
5. *Pomegranate*
6. *Cherry*
7. *Red Apple*
8. *Cinnamon*
9. *Orange Crush*
10. *Tangerine*
11. *Orange Sherbert*
12. *Cantaloupe*
13. *Lemon*
14. *Crushed Pineapple*

15. *Piña Colada*
16. *Buttered Popcorn*
17. *Mango*
18. *Juicy Pear*
19. *Lemon Lime*
20. *Green Apple*
21. *Margarita*
22. *Watermelon*
23. *Berry Blue*
24. *Blueberry*
25. *Plum*
26. *Mixed Berry Smoothie*
27. *Island Punch*
28. *Wild Blackberry*

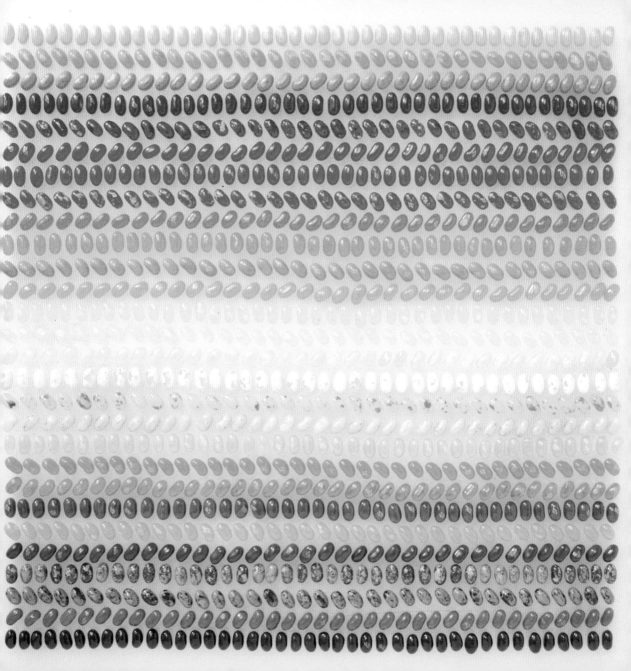

CANDY

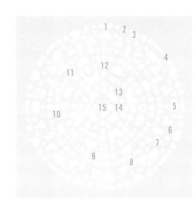

1. *Peppermint Sticks*
2. *Gumballs*
3. *Gummies with Marshmallow*
4. *Gummies with Nonpareils*
5. *Jellies*
6. *Sour Chews*
7. *Gummies*
8. *Marshmallow Peanuts*

9. *Hard Candies*
10. *Lemon Drops*
11. *Sweet and Sours*
12. *Sour Gummies*
13. *Malted Milk Balls*
14. *Conversation Hearts*
15. *Grape Swirl*

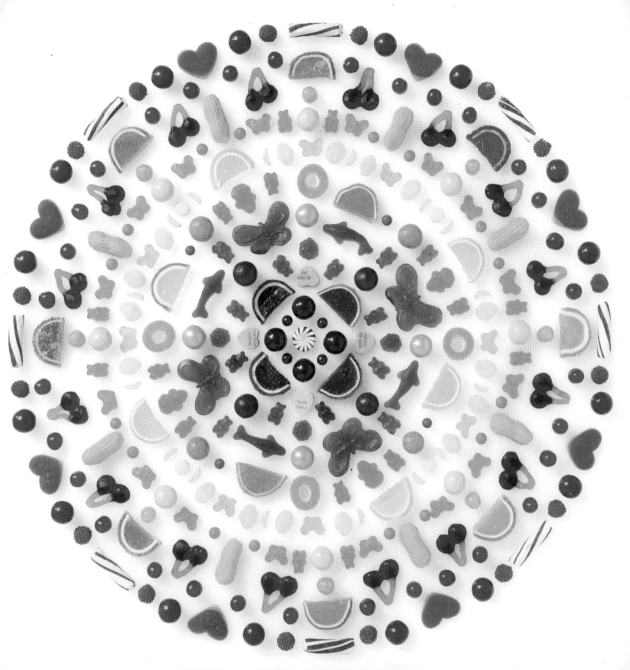

LAWN GAMES

1. *Badminton*
2. *Cherokee Marbles*
3. *Ultimate Frisbee*
4. *Kubb*
5. *Disc Golf*
6. *Lawn Darts*

7. *Pétanque*
8. *Croquet*
9. *Cornhole*
10. *Quoits*
11. *Bocce*
12. *Horseshoes*

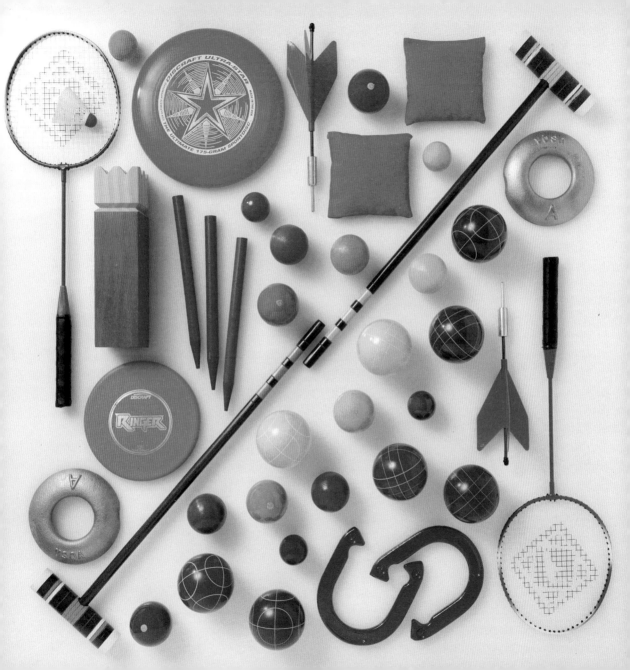

ARCHERY

1. *Longbow*
2. *Bow Stringer*
3. *Finger Tabs*
4. *Armguard*
5. *Quiver*
6. *Arrow, Judo Point*

7. *Arrow, Flu-Flu*
8. *Arrow, Bullet Point*
9. *Arrow, Bowfishing*
10. *Arrow, Broadhead*
11. *Arrow, Field Target Point*
12. *Arrow, Blunt Tip*

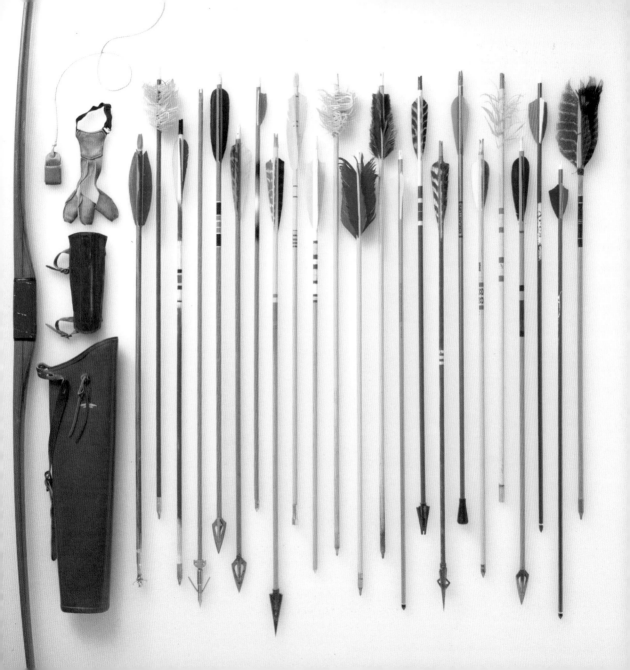

FISHING

1. *Squid*
2. *Worms*
3. *Spring Float*
4. *Musky Streamers*
5. *Bucktail Jig*
6. *Spoons*
7. *Surface Crawler*
8. *Round Bobber*
9. *Pole Float*
10. *Plugs*
11. *Articulated Plug*
12. *Rooster Tail Spinner*
13. *Hula Popper*
14. *Jitterbug*
15. *Hook Sharpener*
16. *Wooly Bugger*
17. *Crawfish*
18. *Rattle Spoon*
19. *Articulated Diver*
20. *Winged Ant*
21. *Grasshopper*
22. *Winged Hopper*
23. *Popper*
24. *Fishing Pole*
25. *Sinking Minnow*
26. *Twister Tail Grub*
27. *Jig Heads*
28. *Clouser Minnow*
29. *Buzz Bait*
30. *Frogs*
31. *Frog Spoon*
32. *Fish Hooks*
33. *Dual Propeller Plug*
34. *Sinkers*
35. *Bait Casting Reel*
36. *Diving Minnow*
37. *Frog-Pattern Plug*
38. *Fishing Line*
39. *Walleye Rig*
40. *Walleye Runner*
41. *Needlefish Jig*
42. *Minnow*
43. *Spinning Jig Body*
44. *Salamander*
45. *Finnish Minnow*
46. *Trolling Spinner*

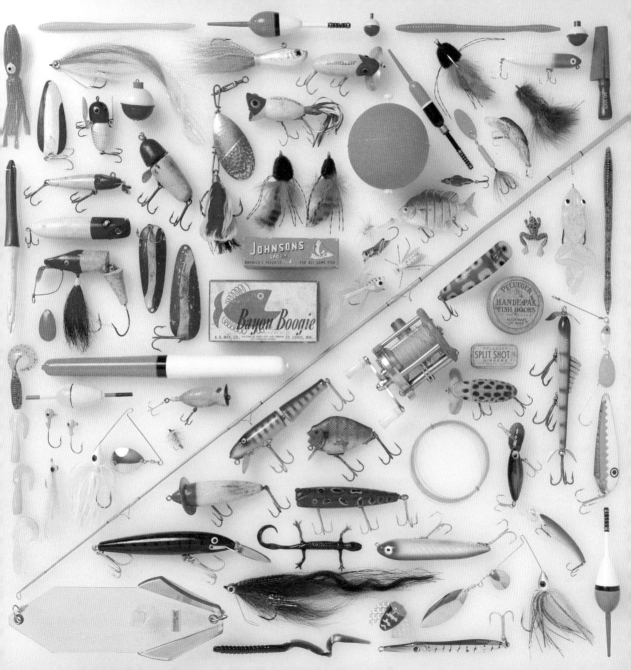

JOHNSONS
SPOON
AMERICA'S FAVORITE · FOR ALL GAME FISH

Bayou Boogie
A. D. MFG. CO. ST. LOUIS, MO.

PFLUEGER
HANDE-PAK
FISH HOOKS

PFLUEGER
SPLIT SHOT
SINKERS

HOUSEHOLD TOOLS

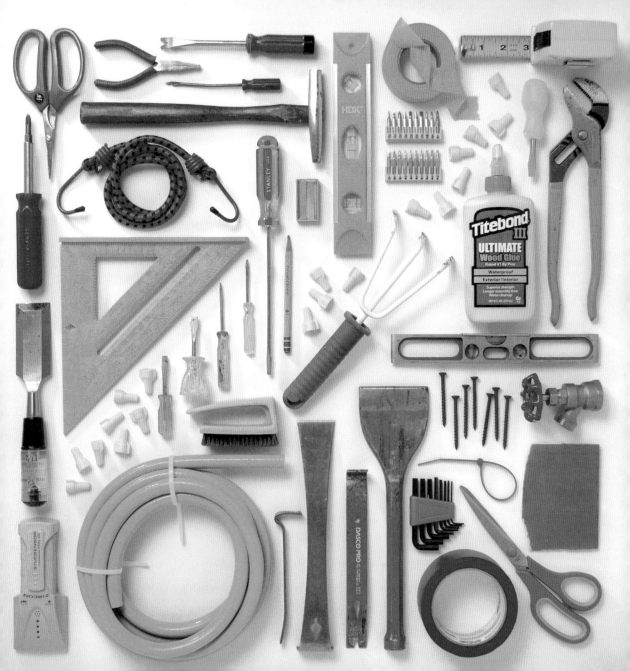

CLEANING TOOLS

1. *Bucket*
2. *Carpet Sweeper*
3. *Whisk Broom*
4. *Computer Brush*
5. *Copper Pot Scrubber*
6. *Counter Duster*
7. *Straw Brush*
8. *Bowl Brush*
9. *Vegetable Brush*
10. *Dish Scrubber*
11. *Deck Scrub Brush*

12. *Sponges*
13. *Corn Broom*
14. *Dust Pan*
15. *Scour Pads*
16. *Scrub Sponges*
17. *Duster Wand*
18. *Fly Swatter*
19. *Lint Trap Brush*
20. *Push Broom*
21. *Rubber Glove*
22. *Cabinet Broom*

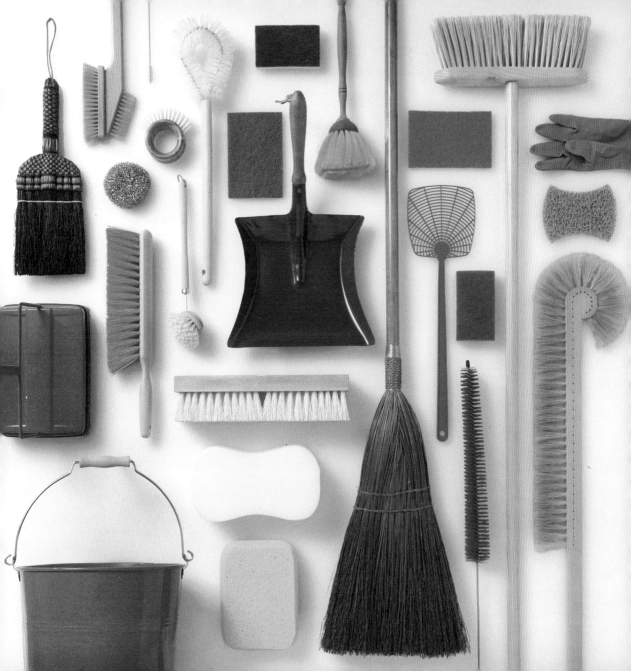

KITCHEN GADGETS

1. *Ice Cream Scoop*
2. *Ceramic Knife*
3. *Mandoline*
4. *Turner*
5. *Strawberry Huller*
6. *Mezzaluna*
7. *Lobster Cracker*
8. *Measuring Cup (1 cup)*
9. *Canning Jar Wrench*
10. *Half Scraper*
11. *Scraper*
12. *Pasta Tongs*
13. *Rolling Pin*
14. *Basting Brush*
15. *Julienne Peeler*
16. *Magnetic Bag Clip*
17. *Orange Peeler*
18. *Measuring Cup (½ cup)*
19. *Melon Baller*
20. *Citrus Knife*
21. *Corn Skewers*
22. *Measuring Cup (⅓ cup)*
23. *Citrus Zester*
24. *Lemon and Lime Juicer*
25. *Corn Zipper*
26. *Bag Clip*
27. *Fruit Muddler*
28. *Garlic Press*
29. *Measuring Cup (¼ cup)*
30. *Fruit Scoop*
31. *Herb Scissors*
32. *Colander*
33. *Citrus Reamer*
34. *Greens Stripper*
35. *Measuring Cup (2 cups)*
36. *Whisk*
37. *Biscuit Cutter (2¼ in)*
38. *Biscuit Cutter (2⅝ in)*
39. *Fish Spatula*
40. *Corkscrew*
41. *Bottle Opener*
42. *Measuring Spoon Set*
43. *Biscuit Cutter (1½ in)*
44. *Jar Gripper*

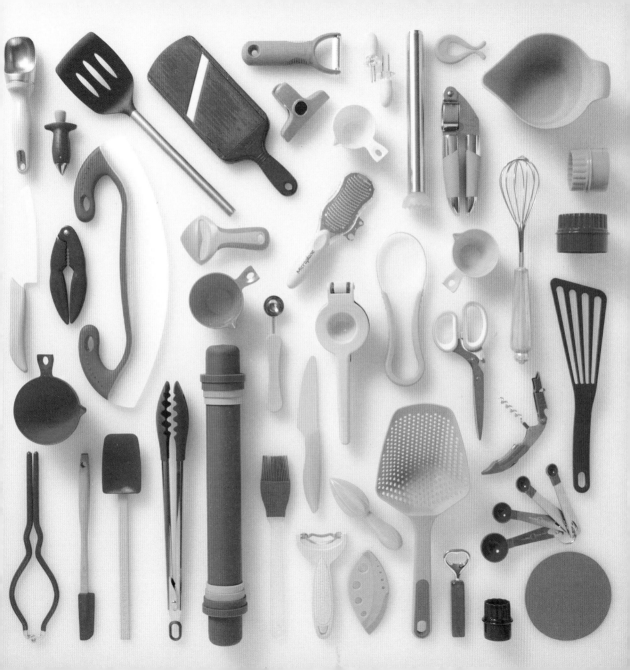

SCISSORS

1. *Carbon Steel Serrated Scissors*
2. *Poultry Shears*
3. *Duckbill Napping Shears*
4. *Blade Shears*
5. *Garden Shears*
6. *Trauma Shears*
7. *Child Training Scissors*
8. *Lefty Scissors*
9. *Floating Blade Scissors*
10. *Folding Scissors*
11. *Grape Scissors*
12. *Deckle Scissors*
13. *All-Purpose Scissors*
14. *Electrician Scissors with Wire Notches*
15. *Bonsai Scissors*
16. *Herb Scissors*
17. *Ceramic Food Scissors*
18. *Pinking Shears*
19. *Zigzag Safety Scissors*
20. *Titanium Scissors*
21. *Wave Safety Scissors*
22. *Food Scissors and Masher*
23. *Embroidery Scissors*
24. *Machine Embroidery Scissors*
25. *Squeeze Scissors*
26. *Marine Shears with Fish Scaler*
27. *Detail Scissors*
28. *Batting Shears*
29. *Nylon Safety Scissors*

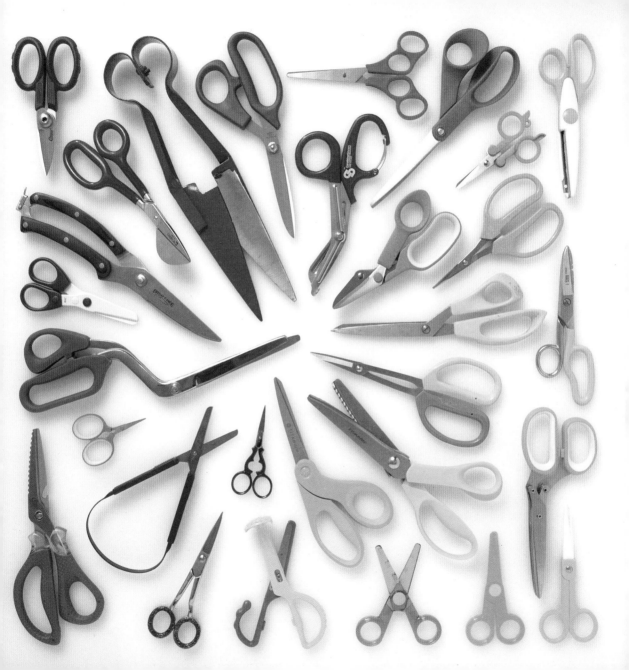

RULERS

1. *Zero Centering Ruler*
2. *Compass*
3. *T-Square*
4. *Finger Grip Ruler*
5. *Ring Ruler*
6. *Protractor*
7. *60° Triangle*
8. *45° Triangle*
9. *Rafter Square*
10. *Yard Stick*
11. *Quilting Ruler*
12. *Parallel Ruler*
13. *Rain Gauge*
14. *Engineer's Scale*
15. *Measuring Tape*
16. *Angle Finder*
17. *Folding Wood Ruler*
18. *Demonstration Compass*
19. *Shellfish Caliper*
20. *Framing Square*
21. *Goniometer*
22. *Flexible Curve Ruler*
23. *Beveled Ruler*
24. *Architect Pocket Scale*
25. *Paper Tearing Ruler*
26. *Hot Hemmer*
27. *Tailor's Tape*
28. *Protractor with Arm*
29. *Shatterproof Ruler*
30. *Acrylic Ruler*

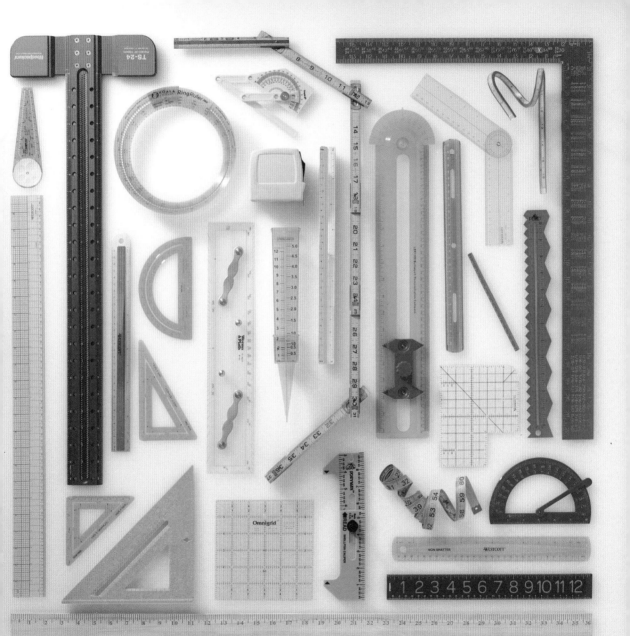

PENCILS

1. *Neon Lead*
2. *Dressmaker*
3. *Pop-a-Point*
4. *Marking*
5. *Beginner*
6. *Grease*
7. *Carpenter*
8. *Triangle*
9. *Charcoal Lead*
10. *White Lead*
11. *Golf*
12. *Extender*
13. *Mechanical*
14. *Square*
15. *Intermediate*
16. *Copying*
17. *Water Soluble*
18. *Bridge*
19. *Yellow Copying*
20. *Sketching*
21. *Wide Tip*
22. *Refillable Ferrule*
23. *Denim*
24. *Woodless Watercolor*
25. *Non-Photo Blue*
26. *Extended Ferrule*
27. *Tapered*
28. *Election*
29. *Colored Lead*
30. *Colored Lead with Ferrule*
31. *Quadrachromic*

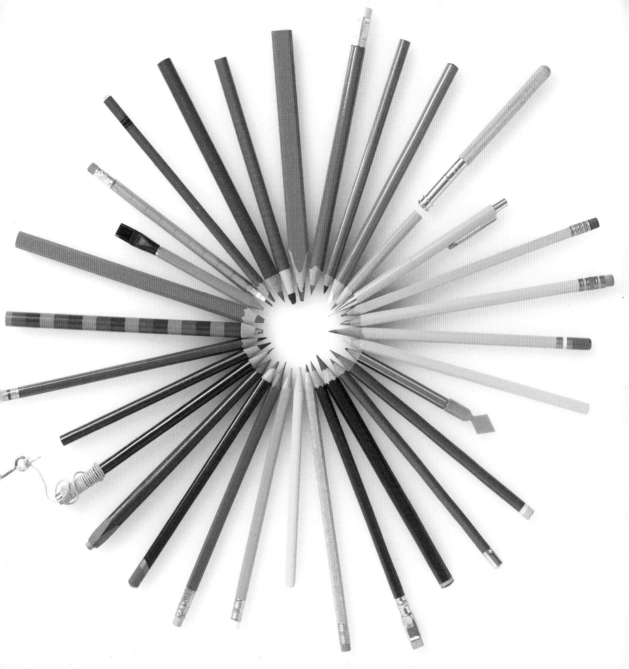

CURRENCY

1. *Twenty-Five Guilders, Netherlands*
2. *Ten Thousand Shillings, Tanzania*
3. *Fifty Rand, South Africa*
4. *Ten Reais, Brazil*
5. *One Hundred Kroner, Norway*
6. *Ten Dollars, Cayman Islands*
7. *One Lempira, Honduras*
8. *Five Dollars, Bahamas*
9. *Fifty Kwacha, Zambia*
10. *Fifty Dollars, Bermuda*
11. *Fifty Dollars, Fiji*
12. *Twenty Thousand Colones, Costa Rica*
13. *Fifty Thousand Shillings, Uganda*
14. *Fifty Guilders, Netherlands*
15. *Five Dollars, Fiji*
16. *Twenty Dollars, Bermuda*
17. *Twenty Reais, Brazil*
18. *Five Thousand Colones, Costa Rica*
19. *Five Dollars, Cayman Islands*
20. *Five Dollars, Singapore*
21. *Ten Thousand Colones, Costa Rica*
22. *Five Guilders, Netherlands*

23. *Fifty Kroner, Norway*
24. *Two Dollars, Bermuda*
25. *Twenty Marks, Germany*
26. *Two Hundred Kroner, Norway*
27. *Two Dollars, United States*
28. *Twenty Euro, European Union*
29. *Twenty Dollars, Fiji*
30. *Two Thousand Colones, Costa Rica*
31. *One Dollar, Cayman Islands*
32. *Ten Dollars, Bermuda*
33. *Five Dollars, Bermuda*
34. *Two Dollars, Barbados*
35. *Ten Guilders, Netherlands*
36. *Ten Florin, Aruba*
37. *Fifty Thousand Colones, Costa Rica*
38. *Ten Dollars, Hong Kong*
39. *Five Thousand Shillings, Tanzania*
40. *One Thousand Ariary, Madagascar*
41. *Ten Dollars, Fiji*
42. *One Hundred Kwacha, Zambia*
43. *Five Kronor, Sweden*
44. *Ten Pounds, Egypt*

45. *Fifty Centimes, France*
46. *One Pence, Falkland Islands*
47. *One Ngwee, Zambia*
48. *One Cent, Bahamas*
49. *Fifteen Cents, Bahamas*
50. *Twenty-Five Sentimo, Philippines*
51. *One Dollar, New Zealand*
52. *One Escudo, Cape Verde*
53. *One Cent, Malta*
54. *Five Cents, Netherlands*
55. *One Pence, New Zealand*
56. *Twenty-Five Cents, Bahamas*
57. *Twenty-Five Cents, Canada*
58. *Five Cents, United States*
59. *Five Cents, Bahamas*
60. *Ten Cents, Bahamas*
61. *Five Shillings, Somaliland*
62. *Five Cents, Bermuda*
63. *Five Cents, Zimbabwe*
64. *Five Cents, Jamaica*
65. *Three Pence, Ireland*

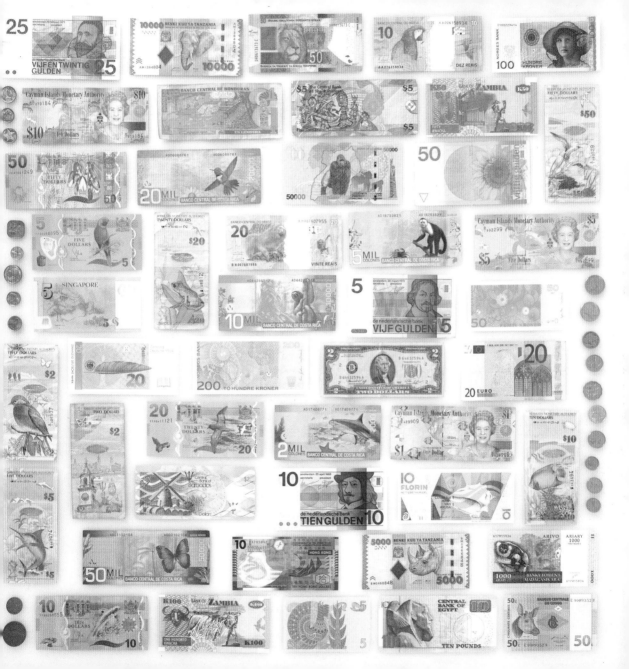

STAMPS

```
1  2   3  4  5  6   6  7  8   9   10  11  12 6
13  14 15 16 9  17 15 18  19 20 6  6 21 22 23 17
  24 25  1  26    4  6    9  15 6  27    28
4  29 28 6   29    15  9  9  4   30 31 12 25
15 32  33 34 9   30  35 22 36 36   6  37 16
  38    9  31   39 9    9  6  36    15 22 6  40
9   41 42 9  6   15  6  9  43 43 43 44   9  41 20
45 46 6 29 9  27   47  9  38 21 48 6   4  20 46
50  6  9  9   9  43 17 51 52  9  6    14 49 15
38 26 6 54 22 29  17 17 3  14    16 29 53 30 16
                                        39
9  26 4  56 9 57 51 22 15 17 6   55 52 16    9
59   9 16 9 9 22 4 60   9  16 15 17 58   30
9 6 20 51 56 2  50  9  56 16  22 4  61 62 15 20
26 43 20 4  4  6  26 63 64 65 6 33 22 66
```

1. *Iraq*
2. *USSR*
3. *Mexico*
4. *New Zealand*
5. *Belgium*
6. *France*
7. *Japan*
8. *Rwanda*
9. *United States*
10. *Iran*
11. *Saint Helena*
12. *Belgium*
13. *Nicaragua*
14. *Grenada*
15. *Germany*
16. *Canada*
17. *Netherlands*
18. *Rhodesia*
19. *Morocco*
20. *Austria*
21. *Finland*
22. *Australia*

23. *China*
24. *Ajman*
25. *Pakistan*
26. *South Africa*
27. *Sri Lanka*
28. *Paraguay*
29. *Spain*
30. *Great Britain*
31. *Hungary*
32. *Rhodesia and Nyasaland*
33. *Guernsey*
34. *Denmark*
35. *Yugoslavia*
36. *Poland*
37. *Norway*
38. *Libya*
39. *Italy*
40. *Cuba*
41. *Portugal*
42. *Argentina*
43. *Zimbabwe*
44. *Trinidad and Tobago*

45. *Venezuela*
46. *Romania*
47. *Kenya, Tanzania, and Uganda*
48. *Tuvalu*
49. *Tanzania*
50. *Indonesia*
51. *Hong Kong*
52. *Israel*
53. *San Marino*
54. *Ireland*
55. *Montserrat*
56. *Bahrain*
57. *Thailand*
58. *North Korea*
59. *Honduras*
60. *Kenya*
61. *Maldives*
62. *Turkey*
63. *Bangladesh*
64. *South Korea*
65. *Nigeria*
66. *Dominican Republic*

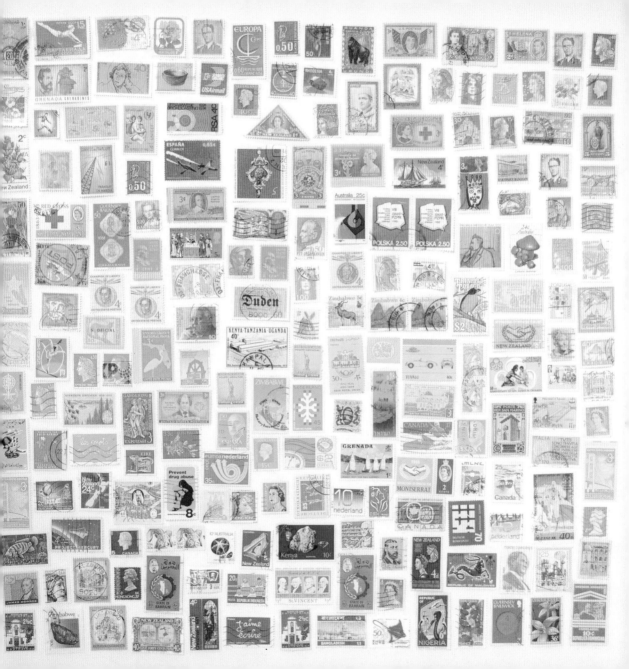

MATCHBOOKS

ENVELOPES

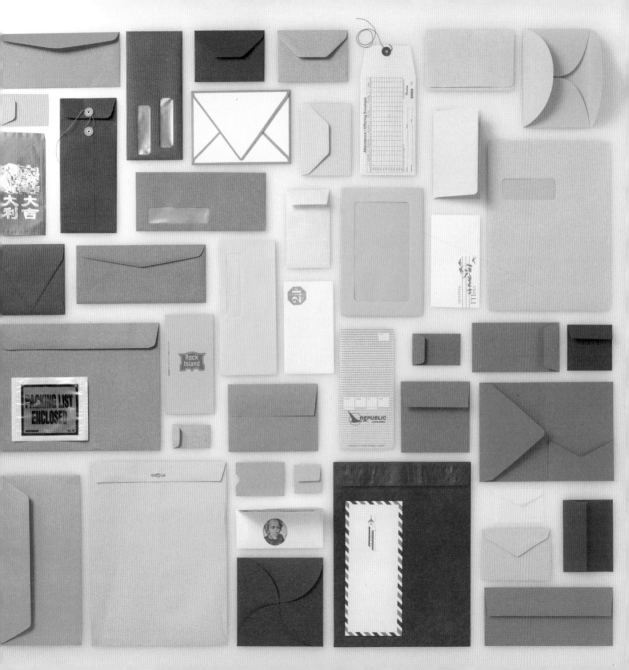

TAPE

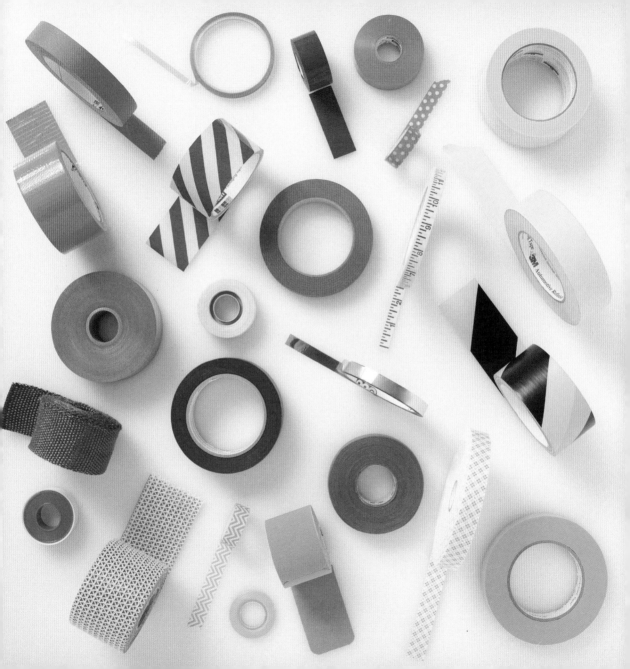

BUTTONS

1. *Celluloid*
2. *Glass*
3. *Bakelite*
4. *Ceramic*
5. *Cloth*
6. *Vegetable Ivory*

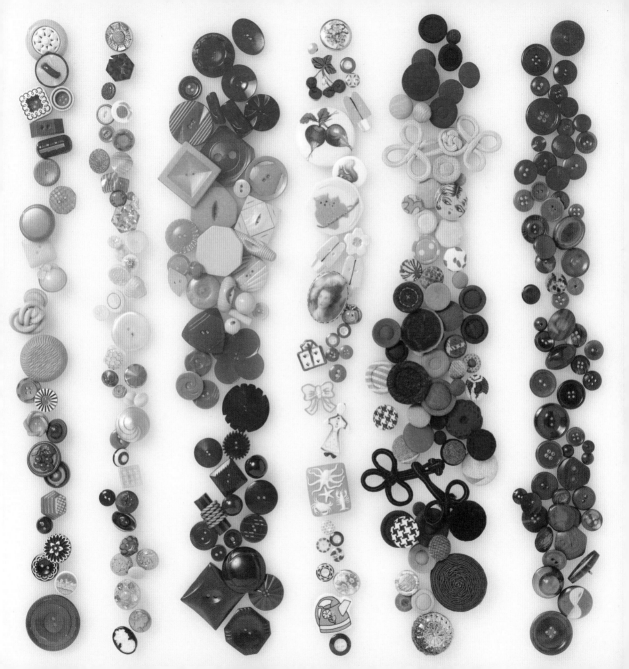

RIBBONS

1. Satin
2. Organza
3. Picot Edge
4. Wired Edge
5. Flocked
6. Polka Dot
7. Pom Pom
8. Rickrack
9. Chevron
10. Herringbone
11. Trim

12. Chiffon
13. Grosgrain
14. Striped
15. Double-Faced Satin
16. Tulle
17. Taffeta
18. Lace
19. Jacquard
20. Velvet
21. Acetate
22. Polyester

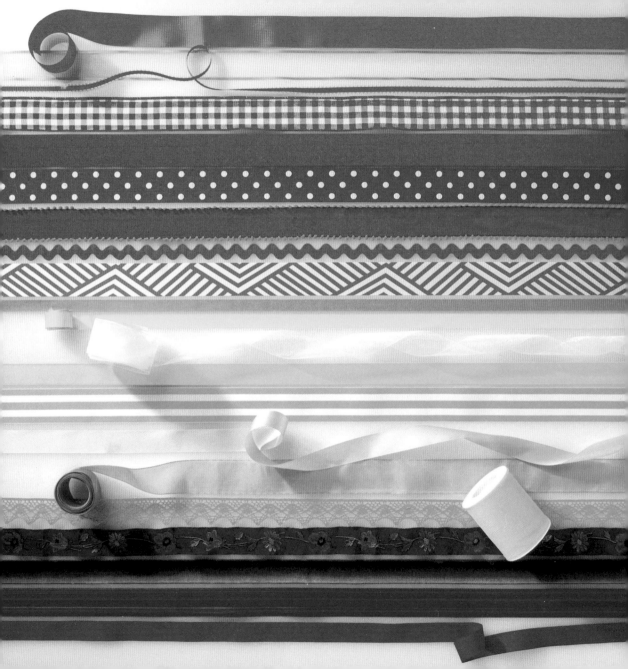

VISUAL INDEX

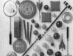
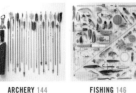
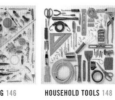
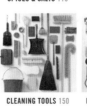
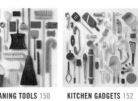
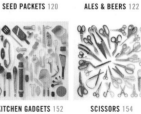
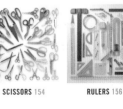